Oils in
10 STEPS

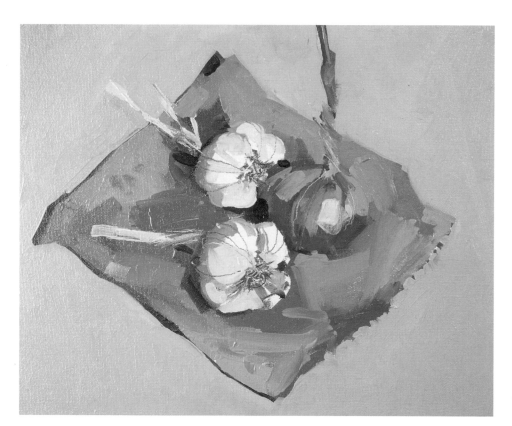

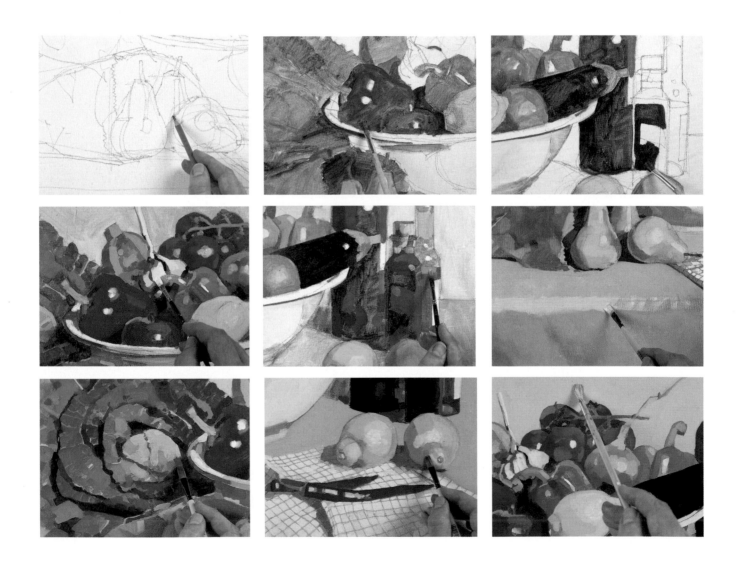

Ian Sidaway

Oils in
10 STEPS

Learn all the techniques you need in just one painting

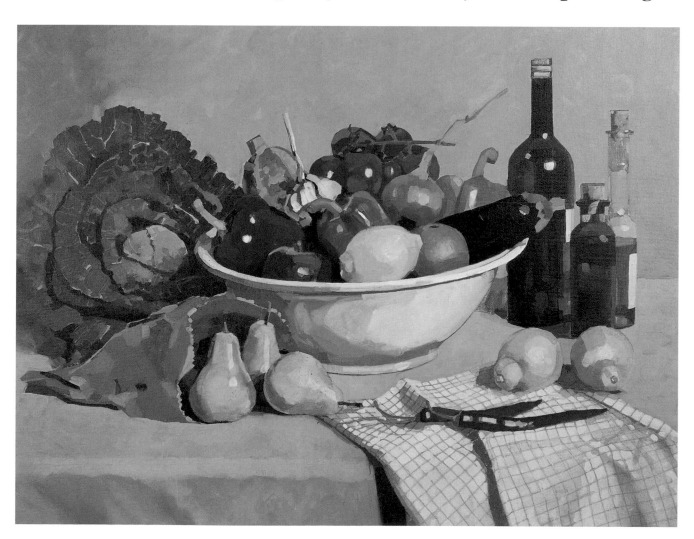

Bounty Books

First published in Great Britain in 2007 by Hamlyn,
a division of Octopus Publishing Group Ltd

This edition published in 2011 by Bounty Books,
a division of Octopus Publishing Group Ltd
Endeavour House, 189 Shaftesbury Avenue,
London WC2H 8JY
www.octopusbooks.co.uk

Reprinted in 2012

An Hachette UK Company
www.hachette.co.uk

Copyright © Octopus Publishing Group Ltd 2007

ISBN: 978-0-753722-55-8

A CIP catalogue record for this book is available from the British Library

Printed and bound in China

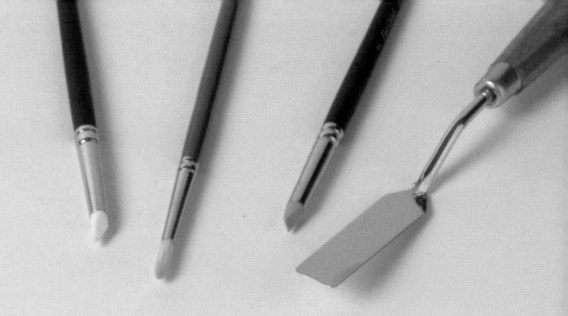

contents

introduction

The 'invention' of oil paint during the early years of the Renaissance revolutionized the world of painting. Thanks to its slow drying time, here was a medium that – for the very first time – could almost tirelessly be manipulated on the painting surface. Artists could now blend colours together to create imperceptible changes in hue and tone, and they could lay transparent glazes of paint one over the other to create a luminosity, brilliance and subtlety of colour that simply had not be achievable before. The continued use of oil paint by thousands of artists over subsequent centuries bears testament to its fantastic potential and adaptability.

Today, oil paint has never been easier to use: the range and quality of colours available is vast; mediums, additives and solvents enable artists to use the paint in any number of different ways; and the wide range of prepared painting surfaces available means that images can be painted in every shape and size. Furthermore, the flexible nature of the paint means that mistakes are easily rectified either by scraping or wiping off the paint or simply by painting over it, making this an extremely attractive medium for beginners.

This book is a basic introduction to the art, teaching you how to create your own accomplished works, from making the first marks to completing a first painting. Arranged almost as lessons, each project of the book focuses on just one aspect of oil

painting. Early stages include laying the foundation for a good painting, how to establish the tonal structure of a painting and how to use colour effectively. Once these steps are mastered, you will learn how to apply the paint using alla prima, glazing and impasto techniques, and how to manipulate the paint by blending, scumbling and using broken colour. Finally, a close look at composition and three painting projects help you to put your acquired knowledge and skills into practice in creating complete works of your own.

Those new to the art will find this a truly versatile syle of painting. Regardless of your subject or the style in which you choose to paint, these tried-and-tested techniques will not only help to build your confidence as an artist, but will bring tremendous satisfaction in exploring oils as a medium.

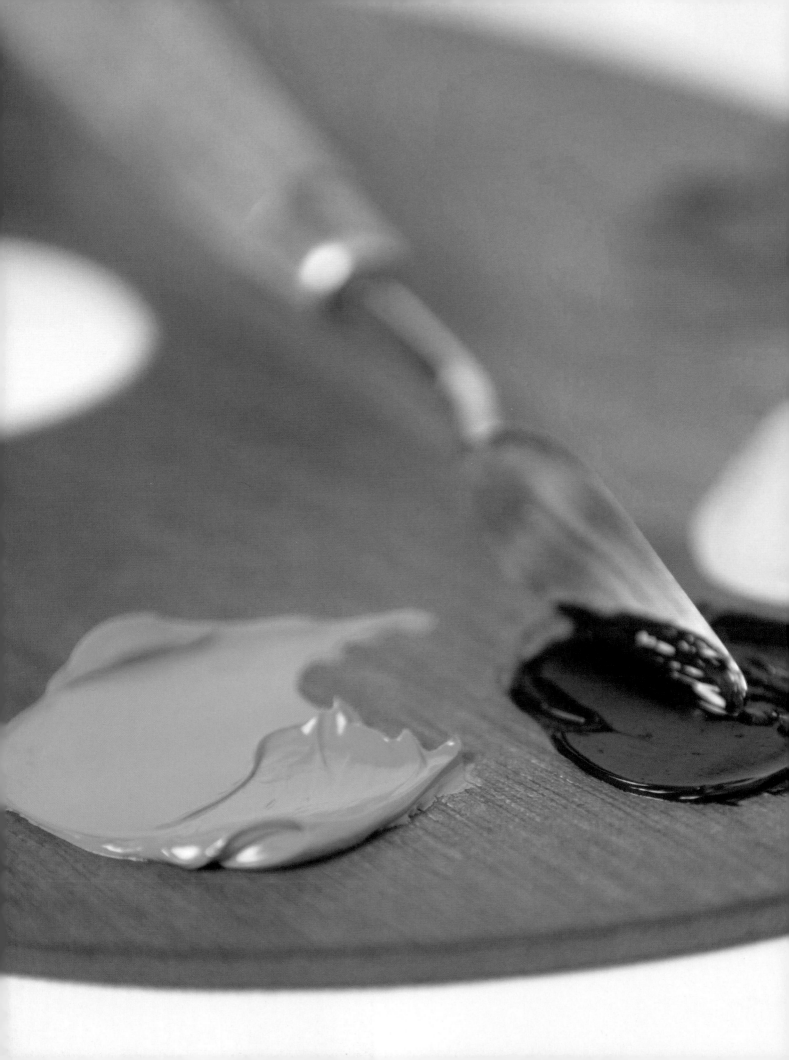

before you begin

choosing the right materials

The materials you need for oil painting are available at most, if not all, art stores. The 'shopping list' below covers the essentials, and those materials necessary for completing the projects in this book. If well looked after, all your basic equipment will last for a long time; you will need to replace paint, mediums and solvents as you use them, but will find that a set of oil paints will produce a considerable number of paintings. Your most regular purchase will be a surface on which to paint and, here, you get what you pay for (see Painting surfaces, page 17). All art materials made by reputable manufacturers are good quality and, as a general rule of thumb, you should pay the most that you can afford: you will not be disappointed.

Shopping list

Soft charcoal pencil
Medium charcoal pencil
Hard charcoal pencil
Stick charcoal
HB graphite pencil
2B graphite pencil
Red pastel pencil
Eraser
Fixative
2.5 cm (1 in) flat synthetic-fibre brush
18 mm (¾ in) flat synthetic-fibre brush
12 mm (½ in) flat synthetic-fibre brush
6 mm (¼ in) flat synthetic-fibre brush
3 mm (⅛ in) flat synthetic-fibre brush
2.5 cm (1 in) flat bristle brush
12 mm (½ in) flat bristle brush
6 mm (¼ in) flat bristle brush
3 mm (⅛ in) flat bristle brush
Small synthetic-fibre fan blender
Silicone paint shaper
Small trowel-shaped painting knife

Turpentine
Alkyd painting medium
Oleopasto or painting butter
Acrylic gesso primer
30 x 40 cm (12 x 16 in) MDF Board x 2
30 x 40 cm (12 x 16 in) prepared
 canvas board
25 x 30 cm (10 x 12 in) prepared
 canvas board x 3
36 x 46 cm (14 x 18 in) prepared
 canvas board
25 x 40 cm (10 x 14 in) prepared
 canvas board
60 x 75 cm (24 x 30 in) prepared
 canvas board
50 x 50 cm (20 x 20 in) MDF board
50 x 60 cm (20 x 24 in) prepared
 canvas board

Oil paints

Titanium white
Cadmium red
Quinacridone red
Cadmium yellow light
Cadmium yellow
Ultramarine blue
Pthalocyanine blue
Raw umber
Burnt umber
Viridian green
Dioxazine purple
Ivory black

OIL PAINT

Essentially, oil paint is made by combining a dry pigment with an oil binder. Most manufacturers offer two grades of paint – student and artist quality – where the cost of the paint is dictated by the cost of the raw pigment used to create it. Artist-quality paint consists of a greater range of colours, containing greater concentrations or more expensive pigments and so tend to be more expensive. It should be noted that all oil paint is intermixable regardless of brand or quality.

The various pigments used to create oil paint exhibit certain inherent characteristics. Some are very strong with a great tinting strength and so need to be used sparingly. Others are less strong and have a very low tinting strength. Some pigments are transparent, which makes them ideal for glazing techniques (see pages 52–59), while others are opaque and have very good covering power.

As you work, keep the screw top and thread of each tube clean. Replace the top properly after use to avoid the paint becoming stiff. To loosen a tight top, either turn it using a pair of pliers or hold it beneath running hot water. Finally, always squeeze the tube from the bottom.

Palette colours

There are hundreds of different colours available, which can cause confusion when choosing a palette. All artists work with a limited range of different tube colours – usually between 10 to 16 in number. Chosen carefully, and with a little practice, these should enable you to mix every colour ever needed.

Basic palette: The twelve single-pigment colours that make an ideal starter palette for the steps in this book.

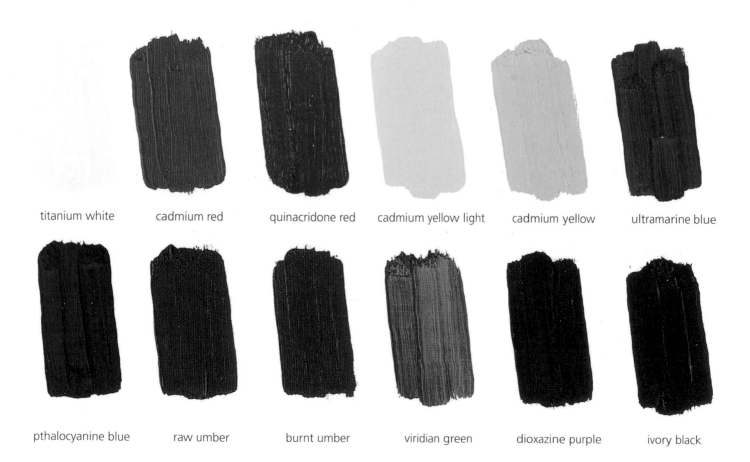

| titanium white | cadmium red | quinacridone red | cadmium yellow light | cadmium yellow | ultramarine blue |

| pthalocyanine blue | raw umber | burnt umber | viridian green | dioxazine purple | ivory black |

The following list of 12 colours is a good starter palette, and will enable you to mix a full range of colours to suit every eventuality. All of the colours are made from a single pigment, which helps to create cleaner, brighter mixes. There is also a good mix of 'warm' and 'cool' colours (see Colour terminology, page 39). Of course, as you develop your own preferences, you may find yourself adding to or substituting some of the number on the list.

When it comes to laying out your palette colours, get into the habit of using the same sequence every time you paint. Eventually you will learn instinctively where each colour resides. The sequence is entirely up to you: the colours could run lightest to darkest, or warm to cool.

The Colour Index code

Although many colours provided by different manufacturers are identical, some with the same name may differ slightly, while others with different names are, in fact, very similar. The reason for this is that the pigment formulae for the colours tend to differ from brand to brand. When looking for specific colours, therefore, you are advised to look for the pigment code given by the Society of Dyers and Colourists and the American Association of Textile Chemists and Colourists, and not the name given to the paint by the manufacturer. This 'Colour Index' code is universal and is printed on the paint tube label along with the colour name.

Colour Index code: The same colour paint from different manufacturers can have a different name. Look for the universal Colour Index code on the tube to be sure of the exact colour you are buying.

A BEGINNER'S PALETTE

All the colours below are artist-quality paints. For the equivalent in student-quality paints, which may use different pigment mixes, consult a stockist who will advise you as to the closest alternative.

Titanium white: PW6
A bright, opaque white that mixes well with other colours. Slow to dry but, unlike other whites, considered non-toxic and rated permanent.

Cadmium red: PR108
Available in light, medium and dark variations, a warm red with good tinting strength and opacity. Slow to dry and rated permanent. Cadmium red light and medium are the most adaptable.

Quinacridone red: PR192
Available in a range of shades and names (Colour Index numbers PV19, PR122, PR207 and PR209), this is a very strong, cool, red with high tinting strength. Transparent and rated permanent.

Cadmium yellow light: PY35
Transparent if used thinly, with good tinting strength. Slow to dry and rated permanent. A relatively cool yellow.

Cadmium yellow: PY37

Reasonably opaque and permanent. A medium-to-slow dryer with good tinting strength. Exact hue may vary slightly according to manufacturer.

Ultramarine blue: PB29

A classic, warm, blue. Permanent and transparent with a high tinting strength. Medium to slow drying time. Exact hue may vary according to manufacturer.

Pthalocyanine blue: PB15

Available under a range of names including Winsor and Monestrial blue, a transparent colour with a very high tinting strength so needs to be used with care. A slow dryer and rated permanent.

Raw umber: PBr7

A fast dryer, useful for underpainting. Permanent and transparent with good tinting strength.

Burnt umber: PBr7

A rich, warm, brown that is fairly transparent and permanent with good tinting strength.

Viridian green: PG18

A rich strong green with a high tinting strength. Transparent and slow to dry. The colour is permanent and forms the basis for a whole range of mixed greens.

Dioxazine purple: PV23

A deep, rich, transparent purple that is considered permanent with good tinting strength. Useful for mixing a wide range of violets and purples.

Ivory black: PBK9

A permanent black with a good tinting strength. Slow to dry and relatively opaque.

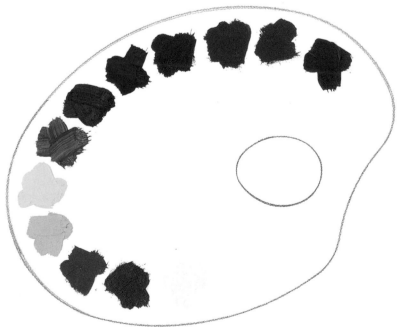

Laying out the palette: Many artists prefer to arrange their palette colours in the same order as they appear in the spectrum, with white at the beginning of the sequence and the neutral browns and black at the end.

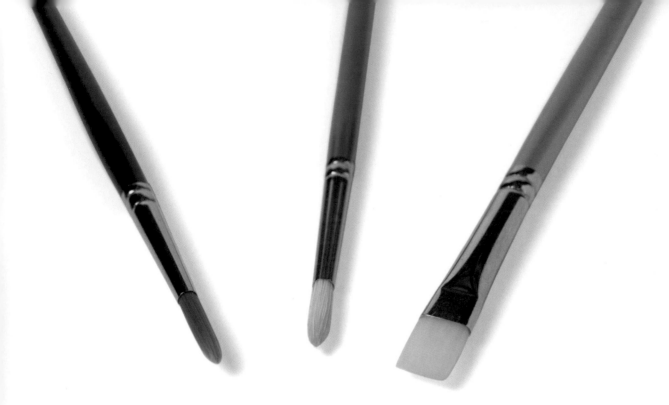

BRUSHES

Brushes for oil painting are made either from natural hair or synthetic fibre. The most common type of hair used is a natural bristle obtained from the hog. This is reasonably hard-wearing and better-quality brushes have a natural split at the end, known as a 'flag', which helps hold and distribute the paint. Brushes made from softer natural hair, such as sable and mongoose, are expensive and less resilient than hog. If you require soft brushes you may find it better to use those made from synthetic polyester. Synthetic-fibre brushes are available in all of the traditional shapes and are reasonably hard-wearing if looked after.

Brushes are sold in a range of shapes and sizes, from very small to large and numbered in progression as size increases. There is no standard to the sizing, so two similar brushes from two different manufacturers may be numbered differently. The size of brush you use relates directly to the size of the painting you are working on.

Oil paint is corrosive and, with time, will ruin your brushes unless they are cleaned well and looked after. Once a painting session is over, wipe the surplus paint from the brush with a rag or a paper towel. Remove excess paint from flat brushes by placing them on a flat surface and scraping a palette or mixing knife down the bristles towards the tip. Once rid of excess paint, rinse all brushes in solvent to soften and remove any remaining paint. Pay particular attention to accumulations at the point where the brush fibres disappear into the ferrule. Once clean, work a little detergent into the fibres and rinse well in lukewarm water. Reshape the bristles and leave to dry, resting upright in a pot or jar.

Brush shapes

Paintbrushes come in many shapes and sizes. Their names may vary slightly from manufacturer to manufacturer but the following brush shapes are the most common.

Round

Pointed or domed and made from soft natural hair or synthetic fibre, rounds can hold a lot of paint and are used for line work, detail and drawing in paint. Larger rounds are used to loosely block in large areas of colour.

Flat

Flats have square ends and long bristles. They are easy to control and are used for precision work, blocking in large areas of colour and for blending. The side of the brush can be used for detail and fine linear marks.

Bright

A flat brush with short bristles, stiffer to use than a long flat. Used to build up thick layers of paint, for impasto work (see pages 68–77) and for precise detail.

Filbert

Named after the nut of a similar shape, the filbert is flat with a domed tip. It is very controllable and used to draw detail and block in large areas of colour.

Fan blender

Used to blend areas of paint together, to create textural effects and for dry brushwork – useful when painting landscapes. Avoid mixing paint on the palette with the fan as you will quickly spoil its shape.

PAINTING KNIVES AND SHAPERS

Knives

There are two types of knife associated with painting. The first is the palette or mixing knife. Made from plastic or stainless steel these knives have a long, flat blade, which is sometimes cranked to a different level than that of the handle to avoid getting paint on the hand. These knives are used for mixing paint, for cleaning used paint off the palette and for scraping paint off the painting surface. They can also be used for applying large flat areas of paint onto the surface. Various shaped painting knives are available for more detailed work, the blades of which are rounded, pointed or angled to enable the application of paint in a distinct way. Always clean knives while the paint is still wet.

Shapers

Paint shapers resemble traditional brushes but, instead of using bristle or hair, the tips are made from a solid, flexible piece of silicone rubber. Various shaped tips are available, which are either soft and pliant or stiff and firm. Shapers are generally used with brushes or painting knives to extend the mark-making repertoire. They are easily cleaned using white spirit or turpentine.

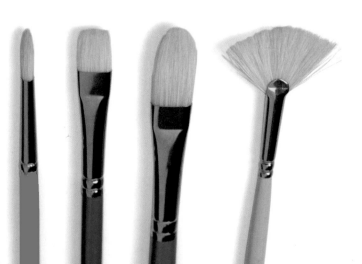

DILUENTS, MEDIUMS, ADDITIVES AND VARNISH

Diluents

Diluents, or thinners, are liquids that thin the paint, making it easy to brush out and apply to a surface.

They are also used for cleaning brushes and equipment after use. The two main types of thinner are turpentine and white spirit.

Distilled from pine resin, the best turpentine to use is double-distilled. White spirit is distilled from coal. It is much cheaper than turpentine and evaporates at a faster rate. Many artists use turpentine in their paint mixes and white spirit for cleaning brushes and palettes.

Mediums and additives

Mediums and additives are used to alter or enhance the characteristics of the paint, and are incorporated into the paint as the colours are mixed on the palette. They can increase the flow of the paint, speed up the drying time,

or increase transparency. They are suitable when using glazing techniques, or for creating a matte or gloss finish once the paint has dried. A useful group of additives are the alkyd mediums. These speed up the drying process and increase the transparency and brilliance of the colours. A thick alkyd medium is also available with added silica for increasing the thickness and bulk of the paint, making it ideal for impasto techniques (see pages 68–77). It is most important to use mediums and additives carefully and to follow any technical instructions provided. Always use them sparingly, avoid mixing mediums and always follow the 'fat over lean' rule (see Step 1 Foundation, pages 20–27).

Varnish

Available in matte and gloss finishes, varnish is used as a covering to protect the painted image against dirt and atmospheric pollution. Applying varnish also unifies the colours. Oil paint needs to be completely dry before applying a coat of varnish. Many artists choose not to varnish their paintings.

SIZING AND PRIMING

Oil pant is corrosive and will, in time, cause the surface on which it is painted to deteriorate unless it is properly protected. This is done by 'sizing' and 'priming' the surface in order to create a protective barrier between the paint and the surface.

The advent of acrylic paint has provided various mediums that are ideal for preparing a surface for oil painting, and which do away with the more traditional process of sizing and priming. They are very simple to use and quick to dry; once dry they remain flexible and do not crack. If you wish to prepare a surface where the natural colour of the support material shows, you can apply a coat of clear acrylic matte medium. Acrylic primers are usually referred to as acrylic gesso. They can be used straight from the pot, diluted to ease application and two to three coats should be sufficient for most surfaces. They can be coloured using acrylic paint.

PAINTING SURFACES

The surface upon which a painting is made is known
as the support. It can be made from fabric, paper,
wood or metal. Paper and card surfaces are most
often used for sketching and preparatory work, while
canvas and wood are favoured for painting.

Canvas

The two types of canvas most commonly used are
made from linen and cotton. Available in a range of
'weights' or thicknesses, linen is a beautiful material
to work on: it is very strong with an irregular 'tooth'
or texture, and has a neutral, dull, ochre colour. Once
prepared and stretched, linen has a bounce or play
that positively invites the application of paint. Far less
expensive to buy than linen, cotton canvas is
commonly known as 'cotton duck'. It is off-white in
colour and has a more mechanical weave than linen.
Cotton is very tough and, like linen, available in a
range of weights.

Both types of canvas need to be prepared on a
wooden frame, known as a 'stretcher'. Smaller pieces
can be glued to a flat wooden panel. You can buy
canvas and stretcher pieces yourself, but there are so
many prepared stretched canvases available that, for
the beginner, preparing your own is perhaps an
unnecessary exercise.

Wood

Until the advent of canvas, hardwood panels were the
traditional support for oil paintings. Today there are
various wooden sheet materials that make very good
painting supports. Easy to prepare and inexpensive to
buy, they include plywood, hardboard and medium-
density fibreboard (MDF).

Plywood is made from various types of wood, such
as mahogany, birch and poplar. Thin sheets of the
wood (ply) are laminated together to form large sheets
that can be cut to size. Various thicknesses are
available: thin panels over 30–40 cm (12–16 in) in any
dimension need to be attached to a wooden
framework in order to prevent warping.

Hardboard, or masonite, is made from wooden
fibres glued together to create a sheet. Hardboard is
available as 'tempered' or 'untempered'. Tempered
hardboard is very hard and smooth on both sides,
while untempered hardboard is less hard and slightly
absorbent. The reverse side of untempered hardboard
has a rough, coarsely patterned surface. Both sides
can be painted on.

MDF is a relatively new surface. The sheets are
available in a range of thicknesses, are not prone to
warping and are similar to linen canvas in colour. The
boards are inexpensive to buy and smooth on both
sides. MDF is very stable and only prone to
deteriorate if allowed to become wet.

Paper and card

Any paper can be painted on, if it is sized and primed (see page 16). Heavy, rough-textured watercolour papers are particularly effective. It is also possible to buy paper that has already been impregnated in order to prevent the oil in the paint corroding the paper fibres. This paper has a textured surface that resembles the weave of a canvas. Card can also be used and, like paper, needs to be effectively sized and primed. Prepared 'canvas' boards are available made from card with a canvas-like paper laminated to the surface. These are found in a range of sizes and different textures.

PALETTES

The surface on which colours are arranged and mixed is called the 'palette'. It should be flat and large enough to accommodate both your range of colours and the resulting mixes. For this reason, it pays to buy the largest palette that you find manageable. Traditional oil-painting palettes are made from hardwood and are rectangular or kidney shaped, with an indentation and a hole at one end for gripping by the thumb of the hand that also holds the brushes. Melamine-covered wooden palettes and plastic variations are also available, as are disposable palettes, which consist of a block of tear-off sheets of oil-proof paper. Before use, traditional wooden palettes should have linseed oil rubbed into the surface to seal the wood and to prevent the oil being sucked out of the paint.

ADDITIONAL EQUIPMENT

Art stores are full of additional equipment and materials, much of which is unnecessary. One item that may be helpful is an easel. There are many types and designs available, and choice depends very much on how you paint, what you paint, where you paint and your budget.

Easels for studio work tend to be the most sturdy, as they often need to accommodate larger painting surfaces and do not need to be transported from one place to another. Easels for work on location are smaller and tend to fold down into a compact, more easily transportable size. They also often have adjustable legs, which enable the easel to stand firmly on uneven ground. Beginners would do well to invest in a box easel – a compact unit combining an easel with adjustable legs and room for holding paints, solvents and mediums. The whole easel folds into a compact unit and is carried using a strong handle on the side of the box.

Other useful equipment includes empty food tins, or small jars, into which solvent can be poured for cleaning brushes, and rolls of paper towel on which to wipe brushes, clean palettes, generally mop up any accidental paint spills, and to wipe away excess paint from the surface if making a correction. You may also wish to buy small cups, called 'dippers', which clip to the side of a palette for holding solvent and painting medium.

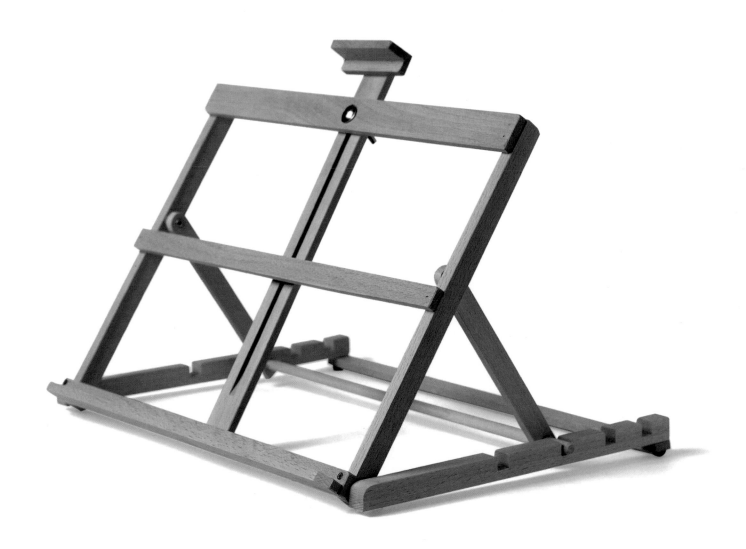

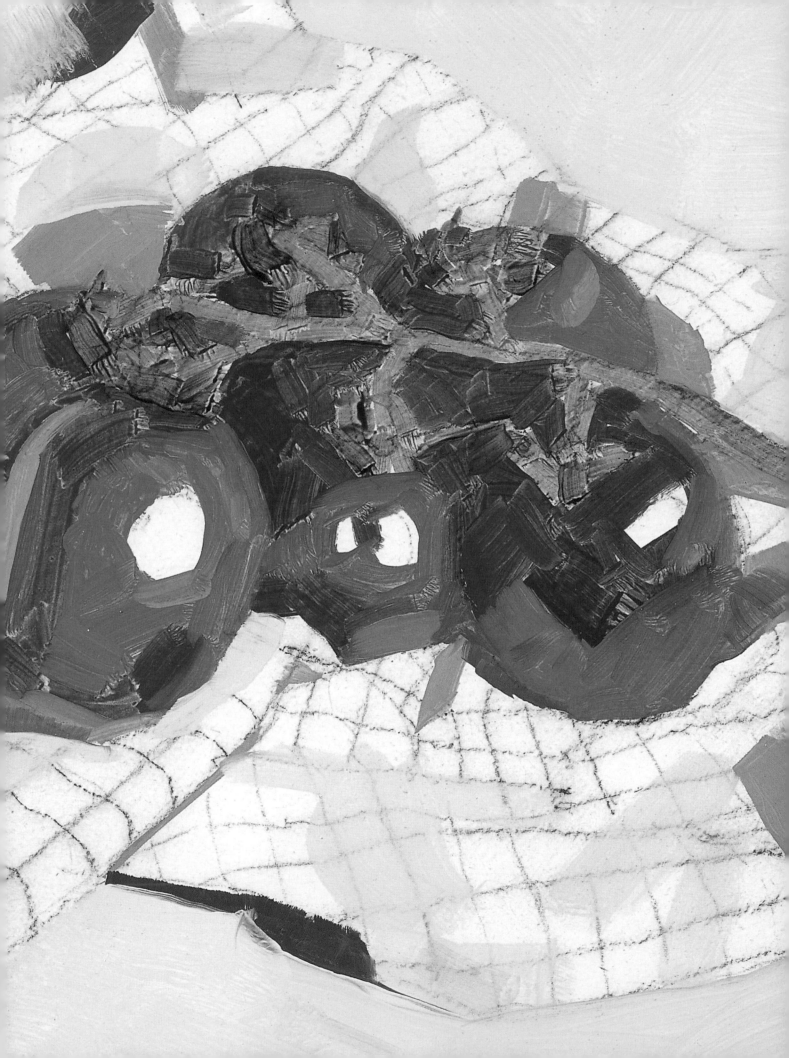

Step 1
foundation

focus: tomatoes

Materials

Medium charcoal pencil
30 x 40 cm (12 x 16 in) MDF board
 prepared with gesso
Soft cloth
Fixative
6 mm (¼ in) flat synthetic-fibre brush
12 mm (½ in) flat synthetic-fibre brush
2.5 cm (1 in) flat bristle brush
Turpentine
The palette:
* *Titanium white*
* *Cadmium red*
* *Cadmium yellow light*
* *Cadmium yellow*
* *Raw umber*
* *Viridian green*
* *Ivory black*

Oil paint dries, not by evaporation, but by a process known as oxidation. The paint absorbs oxygen from the air, which causes chemical changes to take place, altering the physical and chemical properties of the paint and causing it to harden and dry. The more oil content the paint has in the form of binder, or added slow-drying painting medium, the longer it will take to dry and the more flexible that dry paint layer will be.

For this reason, oil paintings are executed using what is known as the 'fat-over-lean' rule (also known as flexible over inflexible). During the oxidation process, oil paint first expands slightly and increases in weight, then begins to lose weight and contract as it dries. If 'lean' paint (paint with no added oily medium, mixed only by adding a diluent, or a fast-drying alkyd medium – see also, Diluents, mediums, additives and varnish, page 16) is painted over 'fat' paint (paint with added oily painting medium), the lean paint will dry first but will crack as the fat layer of paint beneath expands and then contracts as it cures and dries.

Fat-over-lean: The fat-over-lean rule is easy to follow: when painting in layers, simply begin with an underpainting that is more fluid, has less of an oil content and is faster drying than the paint to follow. Then, gradually increase the oil or painting-medium content with each subsequent layer.

UNDERDRAWING

Although you can begin a painting simply by applying paint, many artists like to begin with a drawing. This acts as a guide and can be as simple or as complex as you wish. The drawing is invariably made from life or is a copy from a previously made drawing, painting or photograph. Whatever the source, it enables you to plan out the composition, making adjustments and corrections at an early stage. It is worth noting that too complex a drawing can actually inhibit the painting process by persuading you simply to 'fill in' the drawing rather than using paint and brush to explore and develop the subject beyond the lines of the drawn image.

You can make an underdrawing using any number of drawing materials, although you should avoid marker pens, as the dye tends to rise and read through even relatively thick layers of paint. Most artists prefer to use either graphite, charcoal, thin oil paint or thin water-based paint. Friable (crumbly), pigmented materials like charcoal, chalk or pastel, may mix with thin paint applied on top, altering the paint colour. If this is a problem spray with a thin coat of fixative prior to applying any paint.

Underdrawing: These underdrawings have been made using (from left to right) graphite, charcoal and thin oil paint.

UNDERPAINTING

An underpainting consolidates the drawing and loosely establishes the main areas of tone and colour, thereby providing a firm foundation on which to continue. Unless you are working on a coloured background that was either made when the surface was primed or added afterwards by applying a wash of thin water-based colour or thin oil colour, you will be faced with the stark white of the painting surface. Underpainting enables you to cover this quickly and will help you gauge the relative tone and colour of your subject more accurately. Underpainting is not obligatory but, when applied, should follow the fat-over-lean rule, using only paint mixed either with a diluent or a fast-drying alkyd painting medium.

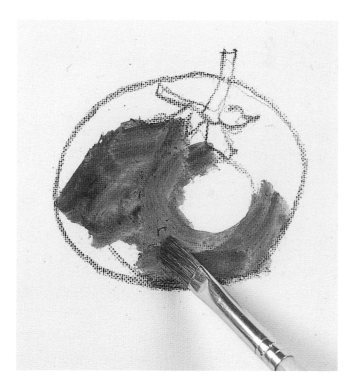

Underpainting: The pigment of the underdrawn charcoal mixes with the first layer of paint, discolouring the paint colour slightly.

PAINTING THE TOMATOES

A bunch of tomatoes is positioned on a napkin. The underdrawing provides enough information to act as a guide for the subsequent addition of paint. The underpainting is applied in simple blocks of colour that provide a good foundation for subsequent applications of colour. Turpentine is added to the colour mixes throughout.

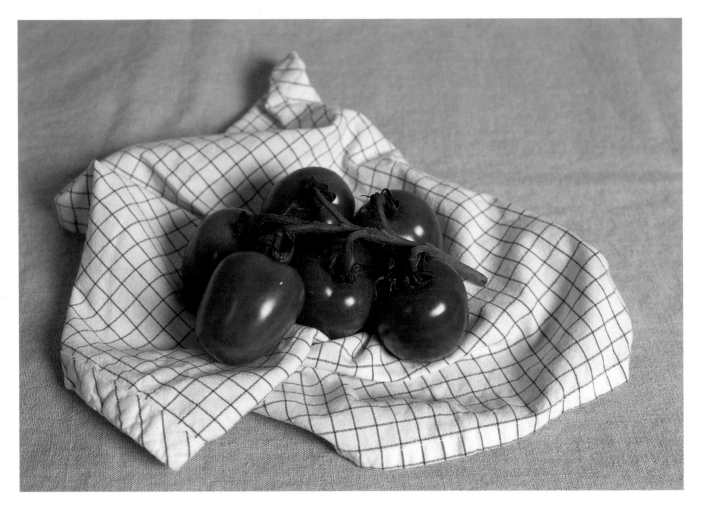

1 Establish the underdrawing. Loosely position the main elements of your composition on the board using the charcoal pencil. Work lightly, drawing simple shapes. If you make a mistake, simply correct it and work on. This outline will be completely covered with paint, so any errors will be lost.

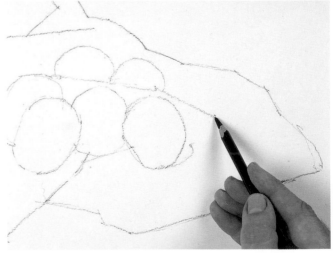

2 Develop the drawing further. Outline any highlighted areas and carefully draw in the pattern on the cloth. This is important, as it shows the way in which the napkin is folded and will act as a guide when paint is applied.

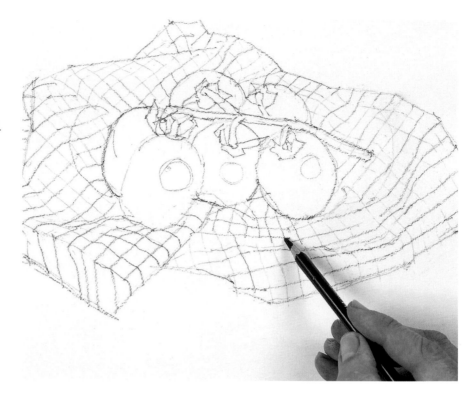

3 Use a soft cloth or paper towel to wipe over the design, removing any excess charcoal from the board. If the drawing is left unfixed, the black charcoal pigment may mix with the oil paint and darken the colours. If you do not want this to happen give the drawing a light spray with fixative.

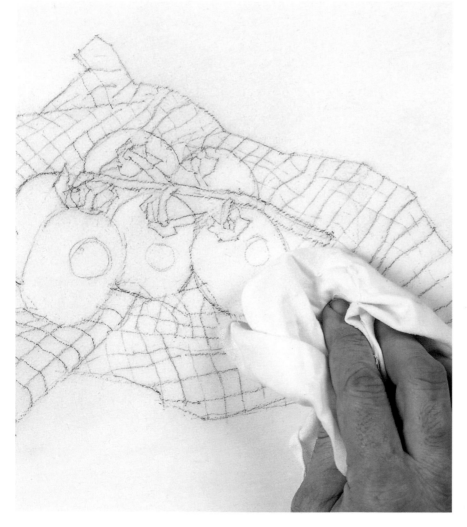

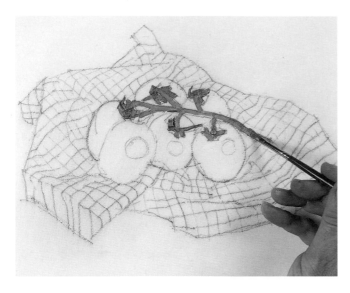

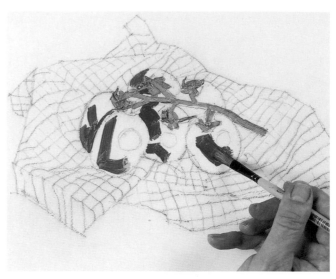

4 Now establish the underpainting. Paint the green tomato stem first. Use viridian green, cadmium yellow, titanium white and raw umber to create a range of greens that approximate those seen. Apply these to the stem using the 6 mm (¼ in) brush, making precise, simple brushstrokes.

5 Next, mix a deep red using cadmium red, cadmium yellow light, raw umber and a little of the previously mixed green. Using the 12 mm (½ in) brush, paint in the darker parts of the fruit.

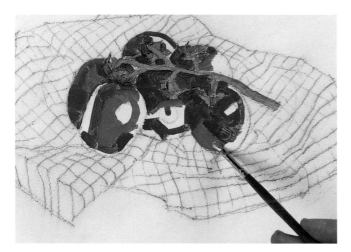

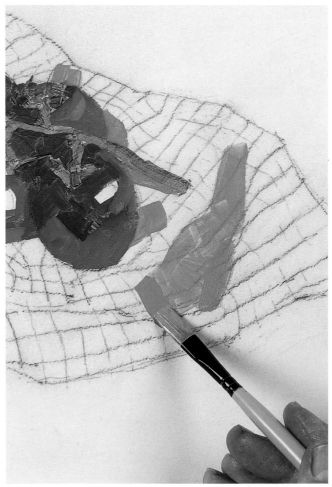

6 Mix a lighter red using cadmium red, cadmium yellow light and a little titanium white, and apply using the 6 mm (¼ in) brush. Keep using simple, direct brushwork and do not become concerned about blending colours together.

7 Make warm grey mixes using ivory black and titanium white into which you add a little of the red mix used on the tomatoes. Using the 12 mm (½ in) brush loosely now, suggest those areas of the cloth that are in shadow. Lighten the mix by adding more white and paint the mid-tone areas. The linear pattern continues to show through the paint and acts as a guide for future applications of colour.

8 Add raw umber to ivory black and a little titanium white, and use the 6 mm (¼ in) brush to paint in the dark shadow on the tabletop beneath the napkin. Add a little cadmium yellow to this mixture, along with plenty of titanium white, to produce a light ochre. Use the 2.5 cm (1 in) brush and loose brushstrokes to apply this to the area surrounding the cloth, carefully working up to the edge of the cloth and the painted shadow.

9 With the tablecloth complete, you have now finished the underpainting and have established both the main areas of colour and the composition of the piece – a very solid foundation on which to build the rest of the painting.

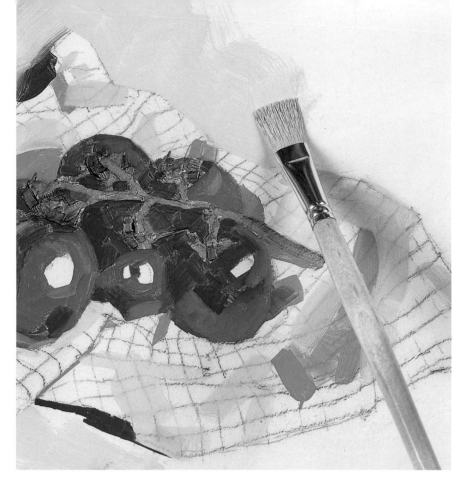

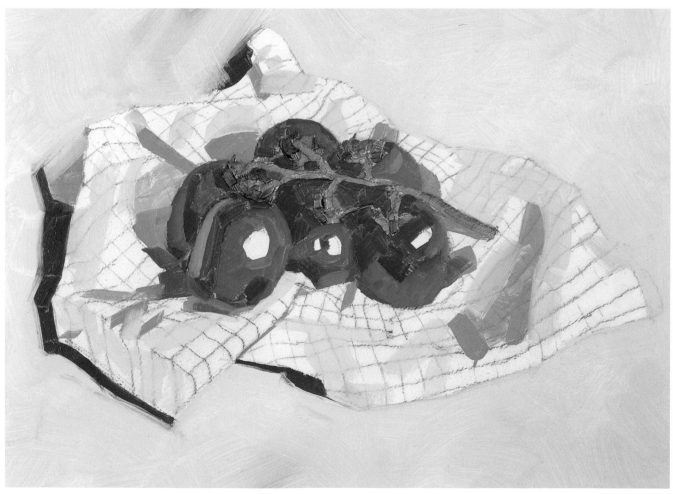

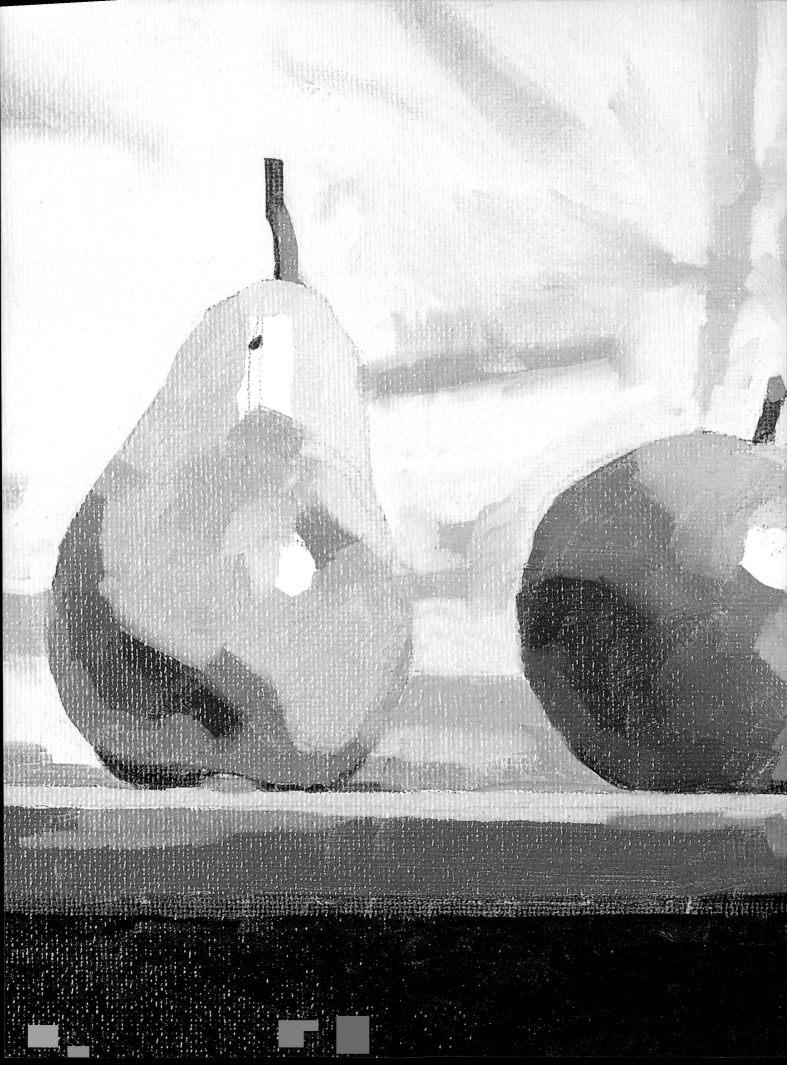

Step 2
tonal
underpainting

focus: pear, apple and lemon

Materials

30 x 40 cm (12 x 16 in) prepared
 canvas board

2B graphite pencil

6 mm (¼ in) flat synthetic-fibre brush

12 mm (½ in) flat synthetic-fibre brush

Turpentine

Alkyd painting medium

The palette:

- *Titanium white*
- *Ivory black*

Monochromatic, or tonal, underpainting is an alternative to the loose, full-colour underpainting used in the previous project (see Step 1 Foundation, pages 20–27). Known as a grisaille, the name is derived from the French *gris* (grey) and means 'grey picture'. Traditionally, the technique was applied prior to using glazing techniques (see pages 52–59), but a tonal underpainting can also be used as preparation for further applications of paint that are not necessarily to be applied as glazes.

The idea is to establish the image using tone only, so that it resembles a black-and-white photograph. The forms are usually modelled to quite a high standard and, as with an underpainting made using full colour, the process also allows the artist to establish and make corrections to the composition.

CREATING A GRISAILLE

When painting a grisaille, it is essential to follow the fat-over-lean rule (see page 22). Unfortunately, ivory black oil paint is particularly 'fat', so only use paint thinned with a solvent or a fast-drying painting medium for this exercise. An alternative is to prepare the underpainting using fast-drying acrylic paint. This is ideal as it removes any problems that might arise if using paint with too high an oil content. Acrylic paint does not use oil as a binder and dries relatively quickly. Note that, while it is perfectly safe to use water-based materials like acrylic paint under oil-based materials, you should never use them over oil-based materials.

If preparing a grisaille strictly as a base for glazes it is usually painted in a 'high key' – that is, without using any really dark tones. The reason for this is so that the glazed colours can be seen against the darker tones. You can use tones of any single colour when painting the grisaille (not just black and white), but be aware that the colour you choose will have a direct, and pronounced, effect on the colour of your glazes as you apply them.

Tonal underpainting: The grey tones for a grisaille are achieved either by mixing the greys using black and white paints (far left) or by using just black paint and a thinner with the white of the support to achieve the tones (left).

PAINTING THE PEAR, APPLE AND LEMON

The fruit is arranged side by side on a table. The low viewpoint creates an ordered, slightly regimented composition lit from the right. The tones are mixed so that they are not as dense or as dark as those seen on the actual objects. Turpentine and alkyd painting medium is added to the mixes throughout.

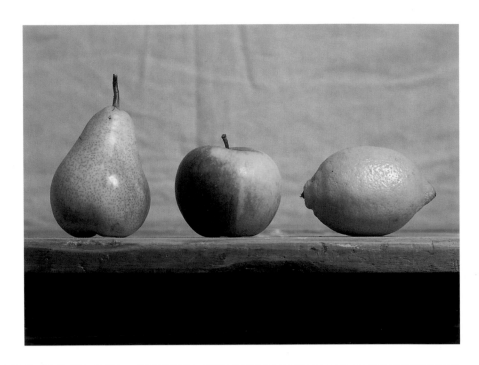

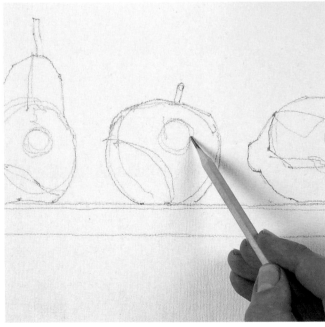

1 Use the 2B pencil to sketch in a basic outline of each object, focusing on the main shape and the position of any shadows or highlights.

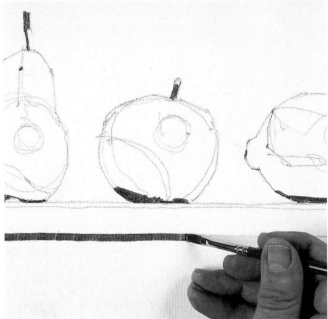

2 Use the 6 mm (¼ in) brush to mix a darkish grey, using ivory black and titanium white, thinned with a little alkyd medium. Paint in the stalks of the fruit and the dark area beneath each piece where it rests on the tabletop. Use the same mixture to paint in a line that represents the bottom edge of the tabletop.

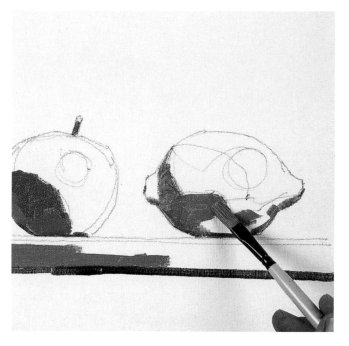

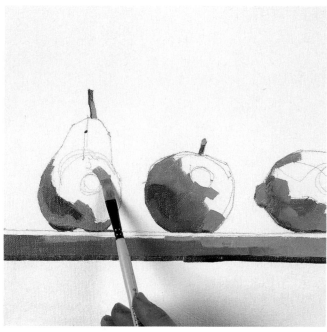

3 Taking the 12 mm (½ in) brush, add a little titanium white to lighten the mix. Use this to carefully paint in the dark shadow tone on the side of each piece of fruit that is facing away from the light. Paint in the dark tone that can be seen on the edge of the table as well.

4 Now lighten the mix further with more titanium white and block in the dark mid tone on the fruit. Brush this gently up to, and slightly into, the darker tone to blend the two together and soften the point at which they join. Use the same mix to complete the edge of the table.

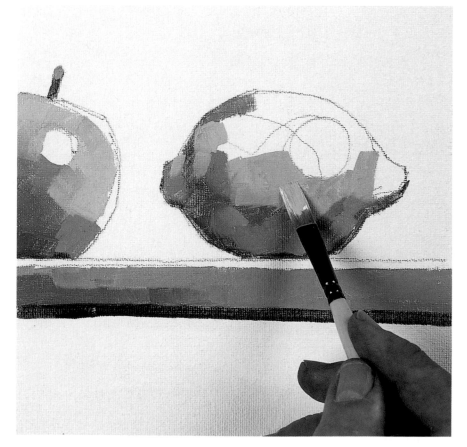

5 Add more titanium white and match the mix to the mid tone of each fruit. As before, work the paint up to the previously applied mixes, working around any highlights.

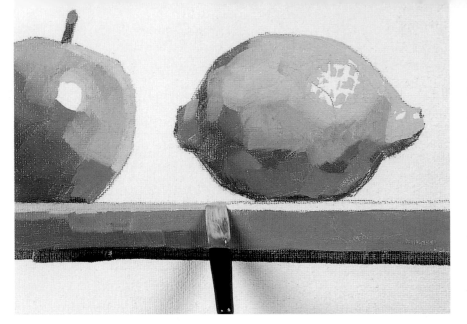

6 Add more titanium white and complete blocking in the tonal transition on each fruit. Using the corner of the brush, add a few dabs of tone into the highlighted area on the lemon to suggest the pitted texture of its skin. Use the same mix to make short, vertical brushstrokes to the topmost part of the table's edge.

7 Note how the mid tones on the fruit match those on the fabric draped behind them. Use the brush, loosely, to block in these areas of tone.

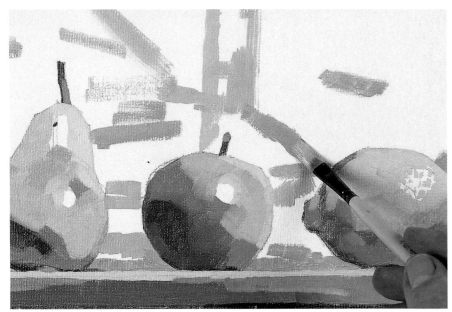

8 Now mix a very light grey and carefully block in the rest of the background fabric. Brush the paint out well so that it mixes with the previously applied tone so that it softens and lightens it slightly.

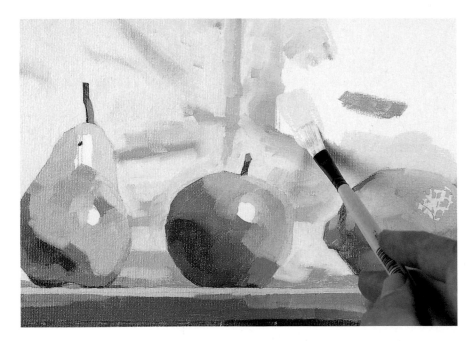

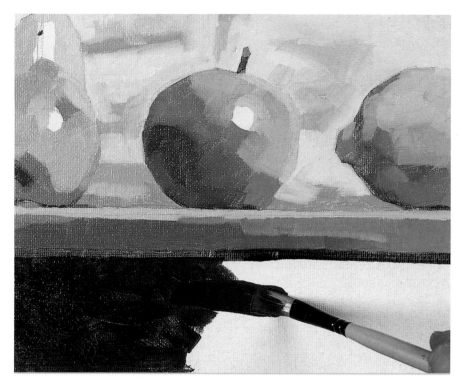

9 Finally, mix a very dark grey and use it to block in the dark area underneath the table.

10 The completed image shows how the various tones of the underpainting can be achieved using relatively few grey mixes, thereby providing an ideal foundation on which to start building up colour.

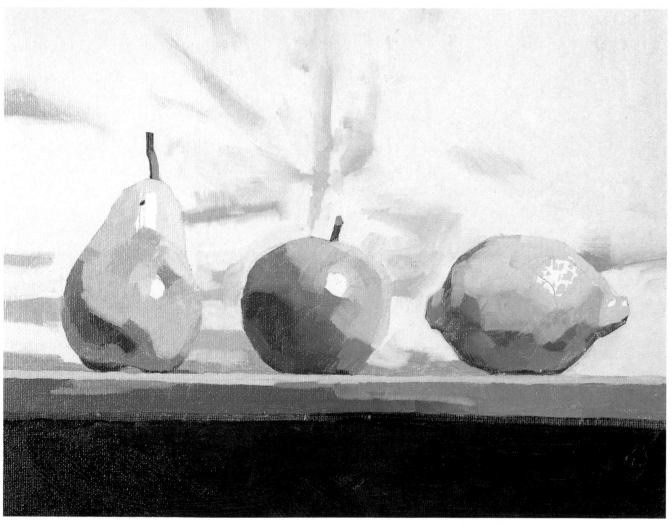

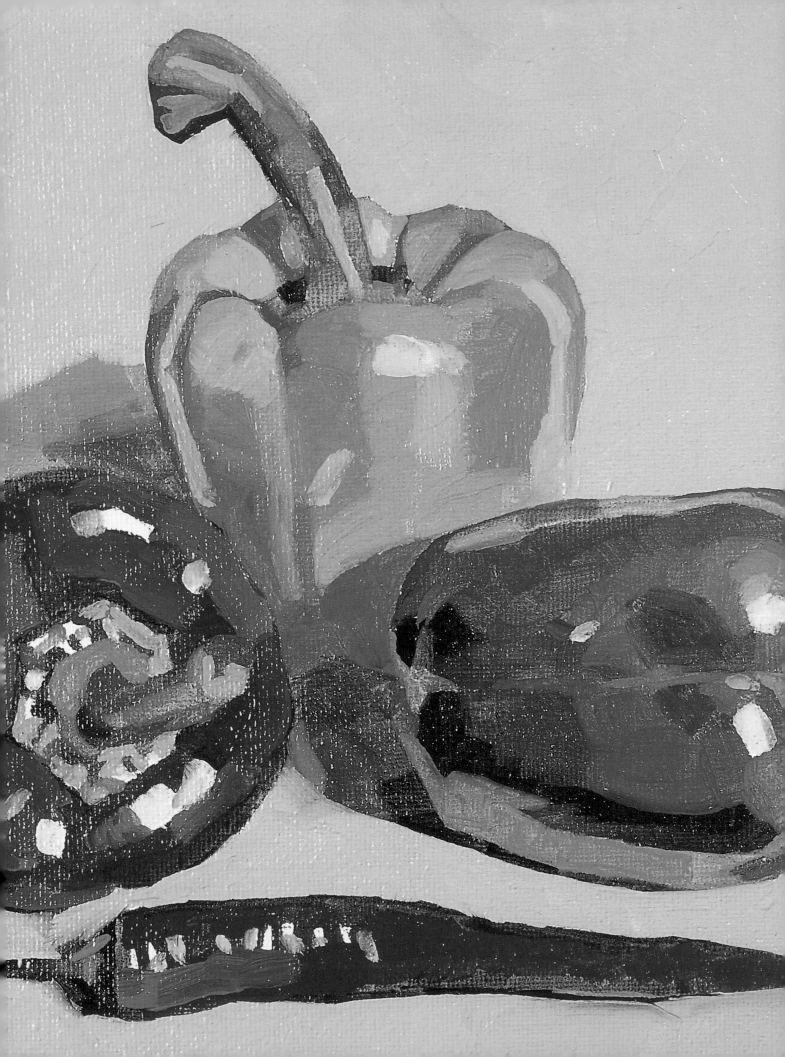

Step 3
colour

focus: peppers

Materials

25 x 30 cm (10 x 12 in) prepared
 canvas board
2B graphite pencil
Fixative
6 mm (¼ in) flat synthetic-fibre brush
12 mm (½ in) flat synthetic-fibre brush
Turpentine
Alkyd painting medium
The palette:
- *Titanium white*
- *Quinacridone red*
- *Cadmium yellow light*
- *Pthalocyanine blue*

Mixing black: To mix black add all three
primary colours together.

Mixing greys and browns: Mix
complimentary colours then add white.

It makes both financial and practical sense to work with a limited palette of colours (see A beginner's palette, pages 12–13). For many who teach painting, the addition of black might be controversial, as it can sometimes result in dull mixes, but used judiciously it can also be extremely useful. Working with a limited range of colours has the additional benefit of teaching you about colour mixing as you learn to approximate and mix the colours you see around you.

WHAT IS COLOUR?

Everything has an intrinsic colour, and we depend on the light falling on an object for its colour to be seen. White light consists of the seven colours of the visible spectrum and is a form of electromagnetic radiation. The seven colours are red, orange, yellow, green, blue, indigo (blue-violet) and violet. Each colour operates on a different electromagnetic wavelength. That we see an object's colour depends on some of these wavelengths being absorbed by the object while others are reflected back to the viewer. For example, a red apple is perceived as being red because red wavelengths are reflected while all others are absorbed; black is seen when all of the wavelengths are absorbed, and white when all are reflected.

MIXING COLOURS

Mixing pigment colours together is known as 'subtractive' colour mixing. This is because the more colours you add, the duller and closer to black the result. In order to avoid this, it is important to arrive at the correct colour mix by using as few different colours as possible. It is for this reason that the beginner's palette colours are all made from a single pigment. The project that follows uses just three primary colours plus white and demonstrates that, by mixing elements of these colours, a wide range of neutral greys and browns can be created.

Colour terminology

Distinct terminology is used when discussing the properties of colour. If learnt, this terminology makes what can be a complicated subject much clearer and more easily understood.

Colour wheel: This is a diagram that shows colours in a circular sequence that corresponds with the order of spectrum colours that make up white light. It is useful for looking at, and making sense of, colour relationships and terminology.

Primary colours: Red, yellow and blue are primary colours and cannot be made by mixing together other colours.

Secondary colours: Mix together any two primary colours and the result is a secondary colour. Red and yellow make orange, yellow and blue make green, and blue and red make violet.

Tertiary colours: Tertiary colours result when a primary is mixed in more or less equal measure with the secondary next to it. Resulting in red-orange, orange-yellow, yellow-green, green-blue, blue-violet and violet-red.

Complimentary colours: Complimentary colours are those colours that fall opposite one another on the colour wheel. When placed next to each other they have the effect of making one another look brighter owing to what is known as simultaneous contrast. The effect is very different when the colours are mixed together. This has a neutralizing effect on the colours, resulting in a range of greys and browns.

Colour temperature: Colours are generally considered to be either 'warm' or 'cool'. Red, orange and yellow are considered warm, while green, blue and violet are considered cool. The issue is complicated somewhat in that each colour has warm and cool variants depending on its colour bias.

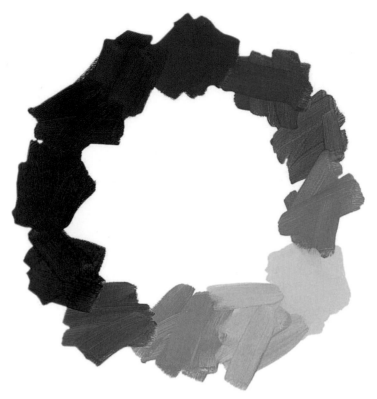

The colour wheel: This 'wheel' shows primary, secondary and tertiary mixes.

Hue: This is simply another name for colour. Ultramarine blue, cerulean blue and cobalt blue are all hues albeit a similar colour.

Value: This is a term used when discussing tone, and describes the relative lightness or darkness of a particular colour.

Saturation: This describes the relative intensity of a colour. Colours that are similar in hue will have different intensities. Cadmium yellow is a highly saturated bright yellow while Naples yellow is not.

Harmony: Certain colours work better together than others, and are called harmonious. There are several different groups of these. Monochromatic harmony is achieved by using various tones of the same colour. Analogous harmony uses those groups of colours that are close together on the colour wheel. Complimentary harmony is achieved by using groups of colours that appear opposite one another on the wheel.

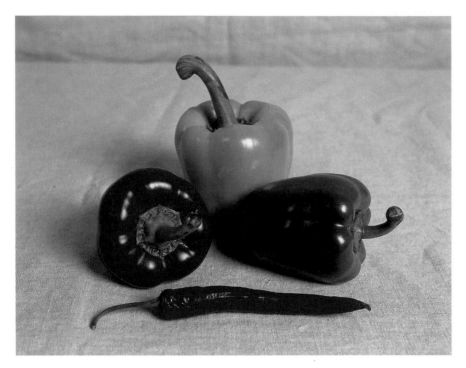

PAINTING THE PEPPERS

Three different-coloured peppers and a chilli are arranged in a simple composition and are painted using just three primary colours and white. This is an excellent exercise, forcing the artist to think very carefully about the colour mixes made. Remember that very small additions of colour can change a mix dramatically. Turpentine and alkyd medium are added to the mixes throughout.

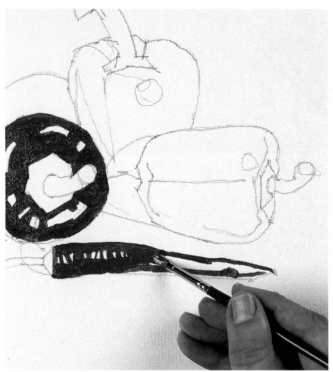

1 Use the 2B pencil to sketch in the position of the four objects. In order to prevent the graphite mixing with the paint colours, spray the drawing with fixative. Mix quinacridone red with cadmium yellow light to create a warmer red, and subdue this by adding a little pthalocyanine blue. Apply the colour to the darker areas of the red pepper and red chilli using the 6 mm (¼ in) brush.

2 Add more red and yellow to the same mix to create a warm, bright, red and use this to block in and establish both the red pepper and the chilli. Work around those areas that catch the highlights, leaving the white of the support to show through.

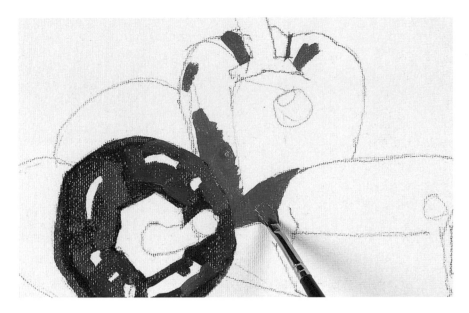

3 Add a little yellow and titanium white to the red mix and work the colour around the edge of the red pepper where the shiny skin picks up reflected colour from the cloth. Now work this colour, over the red previously applied, in those areas around the highlights. Add more yellow to the mix and use this to paint the areas on the orange pepper that are in shadow. Now darken the mix with a little blue and use it to paint in the darkest colour on the skin of the orange pepper.

4 Mix a clean, bright orange using just red and yellow and block in the mid tones on the orange pepper. Lighten the same colour slightly, using a little titanium white and more yellow, and use this to block in the lighter mid tones on the orange pepper.

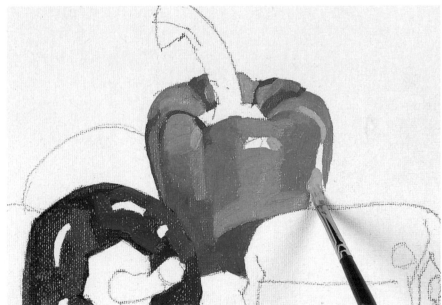

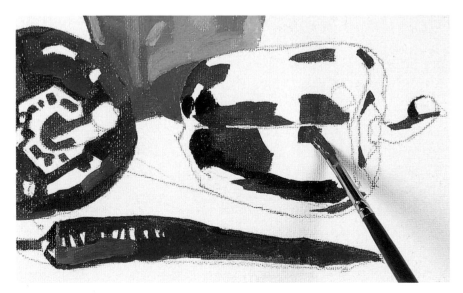

5 Mix a mid-green using the blue and the yellow. This will be very bright so take some of the mix and subdue it gradually by adding red until you have produced a rich, dark green. Use this to block in the darkest passages that can be seen on the stems of the peppers and chilli, and the darkest areas on the green pepper.

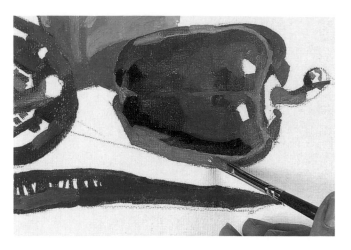

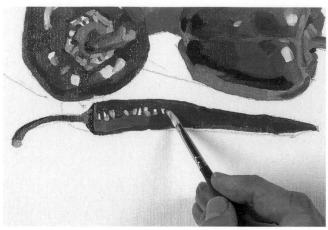

6 Add a line of the dark orange to the top edge of the green pepper to suggest the reflected colour from the orange pepper behind. Taking a little more of the mid-green mix, add more yellow and titanium white. Use this to paint in the mid tones on both the skin of the green pepper and all four stalks. Modify the same mix further with more titanium white to create a light, but subdued, green for the lighter colours around the green pepper's edge.

8 Mix a rich, dark brown by adding small amounts of all three primary colours together with titanium white. This neutral colour provides the basis for the shadows cast by the peppers as well as the base colour for the deep cream cloth. The quantity of each colour used in creating the dark brown needs to be adjusted carefully by adding a little at a time until the colour is correct. Switch to the 12 mm (½ in) brush and use to create a thin line of the colour beneath each pepper and the chilli.

7 The peppers should now be complete. The highlights are still too bright, however, and need to be subdued. Do this by mixing titanium white with a small quantity of the main colour for each pepper. Apply carefully to the unpainted highlights using direct, sure strokes. For small, tight areas turn the brush on its side and use one corner of the flat end.

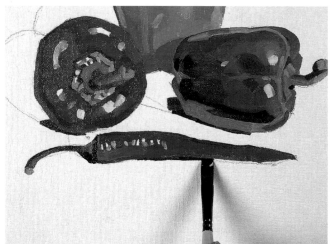

9 Add a little titanium white into the mix to lighten it slightly, then use this to create the shadows cast by the objects, adding a little green to the shadow cast by the green pepper, a little orange to the mix for the shadow cast by the orange pepper, and a little red to the mix for the shadow cast by the red pepper.

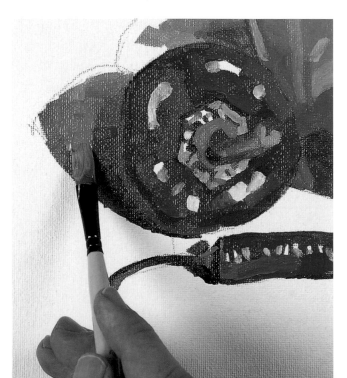

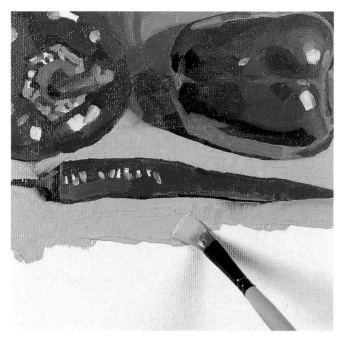

10 For the colour of the cloth, add plenty of titanium white to the original dark-brown mix from step 8 to lighten it. You may find that a little red, yellow or blue needs to be added in order to push the mixture in the right direction. Note how a very small amount of added colour will alter the mix considerably, so add tiny amounts at a time. Carefully cut in around the peppers and their shadows using crisp, direct brushwork, redrawing each object and correcting its shape if you feel you need to.

11 The finished image illustrates how close variations of many colours – including a range of neutral browns – can be made using just three carefully chosen primaries.

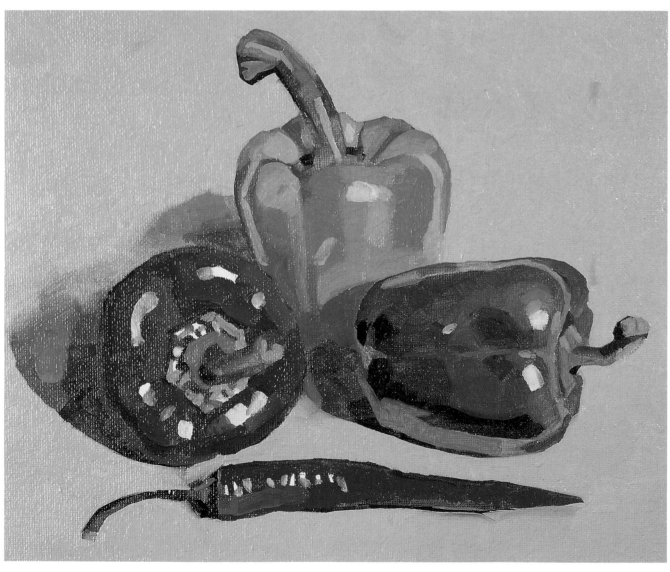

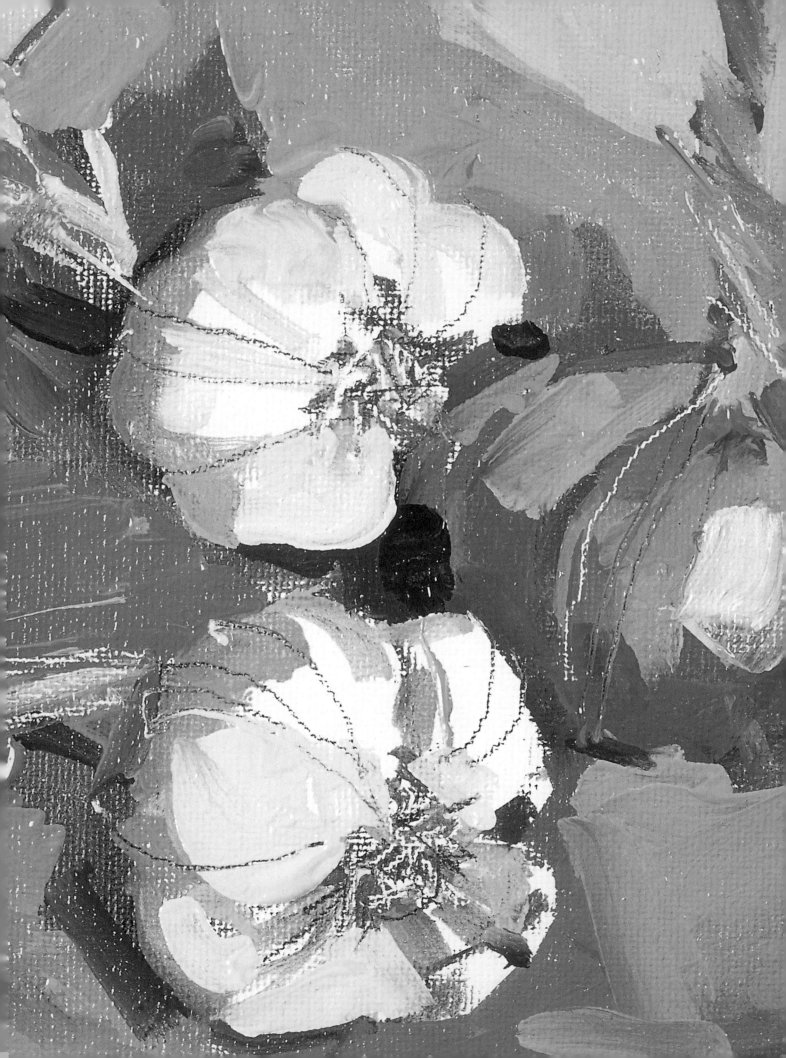

Step 4
alla prima

focus: garlic and onion

Materials

25 x 30 cm (10 x 12 in) prepared
 canvas board
2B graphite pencil
6 mm (¼ in) flat synthetic-fibre brush
Small trowel-shaped painting knife
Turpentine
Alkyd painting medium
The palette:
- *Titanium white*
- *Cadmium red*
- *Cadmium yellow*
- *Ultramarine blue*
- *Raw umber*
- *Burnt umber*
- *Ivory black*

Roughly translated, the Italian expression *alla prima* means 'at the first', and is the term used for a traditional method of painting in which the work is completed – usually in a single session – by painting directly onto the surface without first underpainting. The technique involves using paint that is of a creamy consistency and direct, 'wet-into-wet' brushwork.

Paintings executed using alla prima techniques often have a unique freshness and spontaneity, and are brought to life through the expressive brushwork and exciting colour combinations. This method can be very stimulating and exciting but, for all its apparent spontaneity, nevertheless requires both focus and a clear idea of what it is you want to achieve.

WORKING WET INTO WET

For this method, you construct a painting by applying paint 'wet into wet'. Although colour mixing generally takes place on the palette, a certain amount also inevitably takes place on the support, as wet areas of paint are worked into one another. This mixing should not be confused with blending, where colours and tones are worked together to create smooth transitions (see Blending, pages 60–67). Brushwork should always be direct, unfussy and economical. A painting is usually executed in what can be described loosely as three distinct stages: underpainting, alla prima and adding detail and texture.

UNDERPAINTING

The underpainting establishes the main elements of the composition and should be carried out in a very loose manner using a limited palette or a single colour. Although underdrawing and underpainting can both be very helpful, it is important not to detract from the sense of spontaneity. With any kind of preliminary drawing or underpainting, it is a natural instinct simply to follow it with subsequent work and this should be avoided. Keep drawing to a minimum, preferably using unfixed charcoal

or graphite. Alternatively, use paint thinned with a solvent or mixed with a fast-drying alkyd medium. Brush the paint out well so that it appears relatively 'dry', although it is, of course, still wet.

WORKING ALLA PRIMA

Apply the paint using direct fluid brushwork, mixing colours on the palette and keeping any mixing on the support to a minimum. You can add painting medium to the paint at this point if necessary. Construct the picture gradually, loosely applying broad areas of colour, then work into this with further applications of paint, using direct, sure strokes of the brush. You can usually ignore small details, or simply hint at them using clever brushwork and small flicks or dabs of paint.

ADDING DETAIL AND TEXTURE

Once you have established the image, you rework it, introducing relevant detail with precisely placed brushmarks and dabs of colour or tone made using smaller brushes. To add texture or to 'draw' details you can use a technique known as 'sgraffito' (from the Italian *sgraffire*, meaning 'to scratch'). Using the edge of a painting knife or scraper tool, or even the end of the paintbrush or your fingernail, scrape the surface of the paint to create raised lines or marks with the same intuitive expression of painting alla prima. Avoid overworking, as this will compromise the freshness of the piece.

Wet into wet: The colours are applied 'wet into wet', which means that a certain amount of colour mixing takes place when one colour is worked into the next.

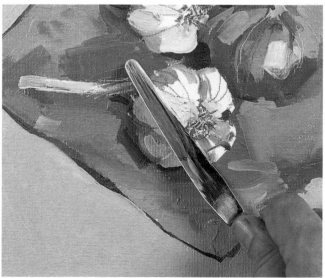

Making corrections: You can make corrections simply by scraping or wiping away the offending area with a mixing/palette knife or a rag. You can then repaint the area.

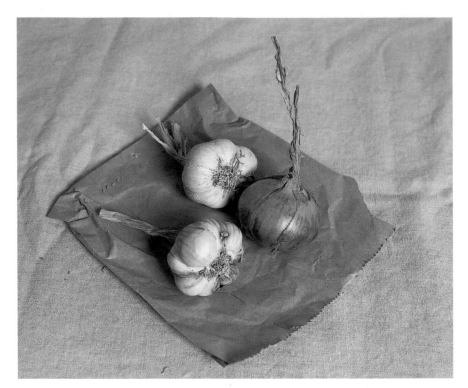

PAINTING THE GARLIC AND ONION

Two bulbs of garlic and an onion are placed on the brown paper bag in which they were bought. The shape of the bag contains the three objects, framing them against the hessian cloth and holding the simple composition together. Turpentine and alkyd painting medium are added to the mixes from step 3 onwards.

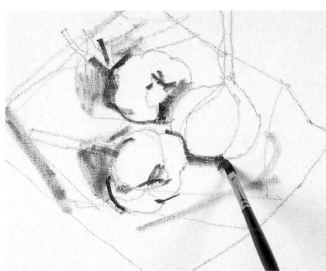

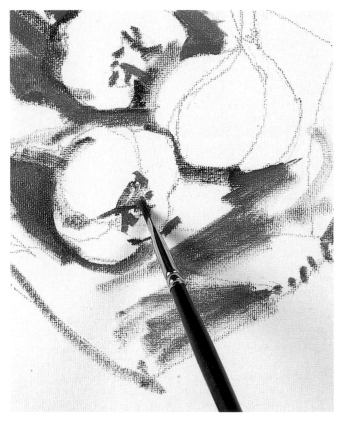

1 Position the objects with a very simple pencil sketch before strengthening the darkest areas using a relatively 'dry' dark mix made from ivory black and raw umber. Add just enough diluent to make the paint workable. Use direct, sure brushstrokes throughout, and avoid 'tickling' or playing with the paint once it has been applied.

2 Add a little titanium white to the mix to lighten it, and use this to paint in the shadow areas and the dark detail seen around the roots on the bottom of each bulb of garlic.

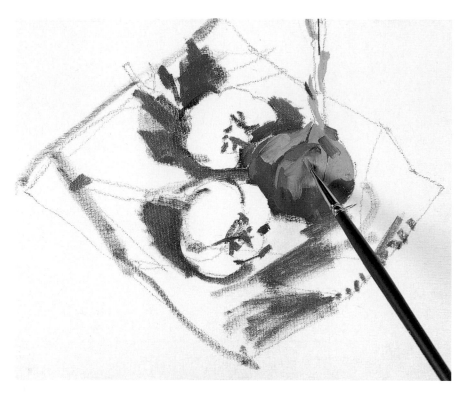

3 Make a deep, reddish-brown by mixing together burnt umber and cadmium red and lighten with a little cadmium yellow. Use this colour to block in the lower half of the onion, making directional strokes that follow its contours. Lighten the mix by adding more cadmium yellow and titanium white and use this new colour to paint in the top half of the onion and to render its dry, twisted stalk.

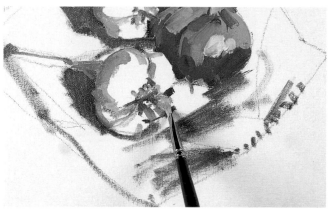

4 Now mix the colour for the garlic. Take some of the lighter onion colour, add more raw umber and a little ultramarine blue. Lighten with titanium white. Work the colour around the contours of the garlic and add a couple of dabs to the side of the onion to suggest the highlighted area.

5 Make a light and a dark version of a cool brown using raw umber and titanium white into which you add a very small amount of ultramarine blue. Use the lighter shade to block in the paper bag and the darker shade to suggest those parts of the bag that are facing away from the light or that are shaded by the garlic. Use the brush carefully to cut around the shape of each garlic bulb, redrawing and redefining the shapes, which now begin to show form.

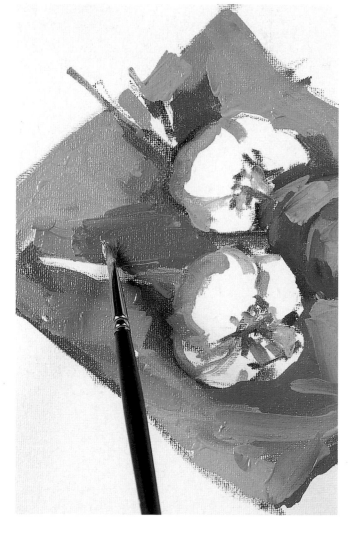

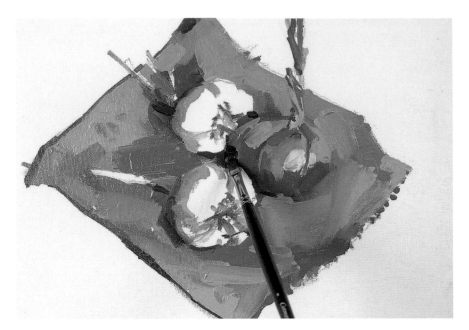

6 Mix a dark brown using raw umber and ivory black, and apply around the edge of the paper bag to create shadow. This has the effect of visually lifting it slightly from the background. Use the same colour to add some darker passages within the shaded areas between the garlic and the onion.

7 Turn your attention to the colour of the tablecloth. Mix what is left of the paper-bag colour with plenty of titanium white and just a little ivory black to knock back, or deaden, the colour slightly. Work carefully up to the edge of the bag and use the very corner of the brush to paint the serrated edge.

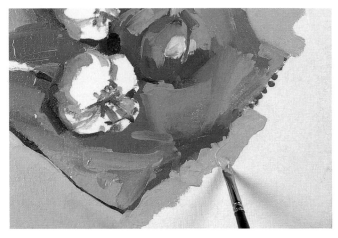

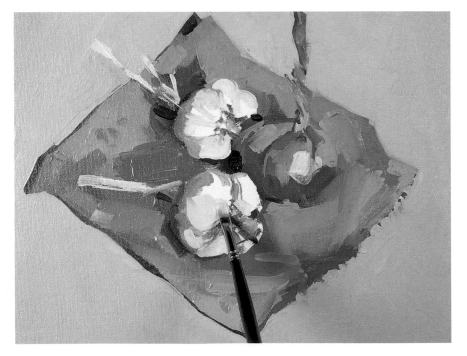

8 Lighten this mixture slightly by adding titanium white, and use to paint the dry, twisted garlic stalks. Using strokes that follow the contours, paint in the light skin of each garlic bulb. Allow the white of the support to show through in places, as this will help to suggest the light, linear pattern that can be seen on their skin.

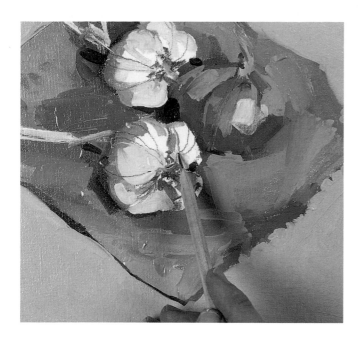

9 Reinforce this effect by adding a few dark lines with graphite pencil.

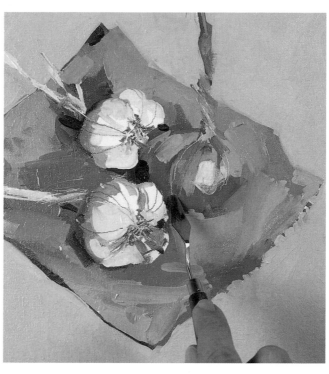

10 Add further detail by scraping into the wet paint using the end of a painting knife (see 'sgraffito' under Adding detail and texture, page 47): add pattern to the twisted stalks, scratch in the garlic roots and add linear marks around the forms of both the garlic and the onion.

11 The final image bears the fresh, spontaneous appearance that is characteristic of an alla prima painting, in which the expressive brushwork brings the subject to life.

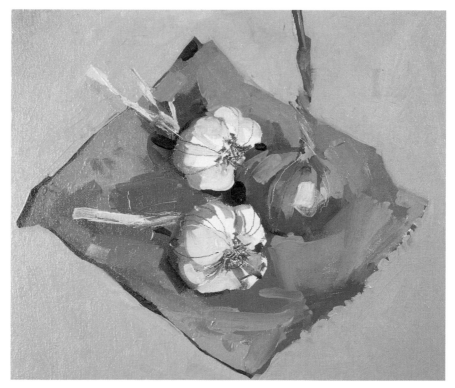

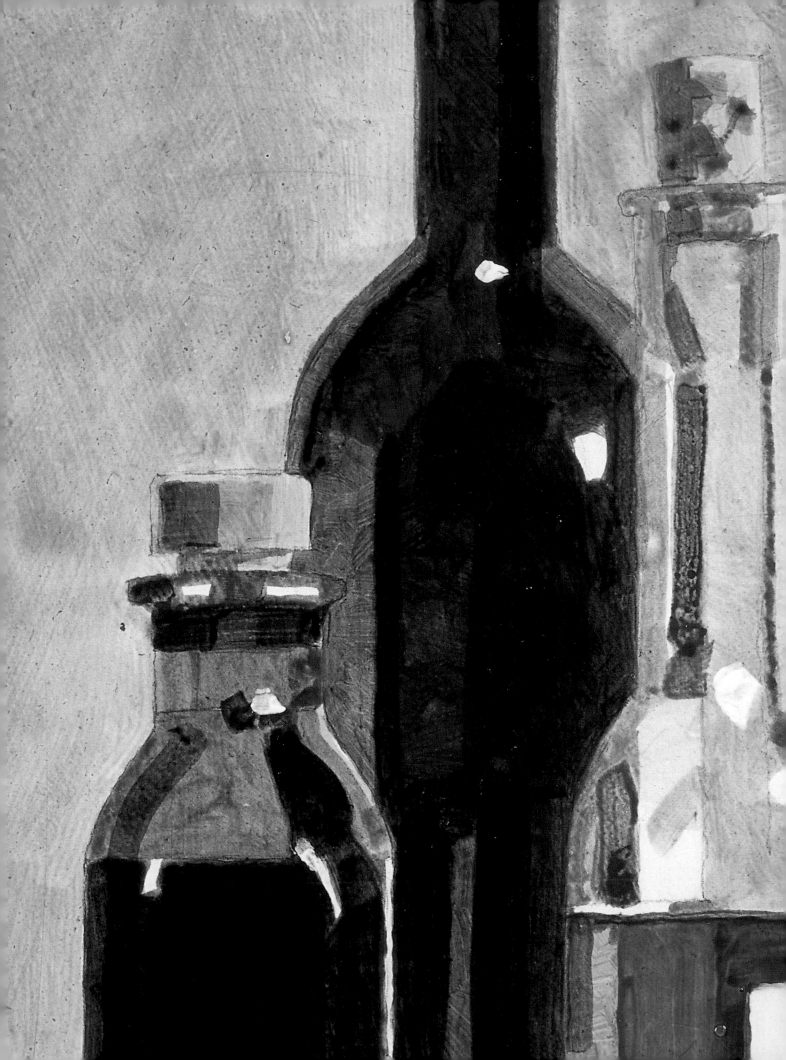

Step 5
glazing

focus: bottles

Materials

30 x 40 cm (12 x 16 in) MDF board
 prepared with gesso
HB graphite pencil
6 mm (¼ in) flat synthetic-fibre brush
12 mm (½ in) flat synthetic-fibre brush
2.5 cm (1 in) flat synthetic-fibre brush
Alkyd painting medium
Glazing medium
The palette:
* *Titanium white*
* *Cadmium red*
* *Cadmium yellow*
* *Ultramarine blue*
* *Raw umber*
* *Viridian green*
* *Ivory black*

Tone: If you paint the grisaille using the correct tones, subsequent thin, coloured glazes will read as colour over the darkest tonal areas.

Traditionally, working with glazes requires the preparation of a monochromatic grisaille or tonal underpainting (see pages 28–35). Once the grisaille is dry, thin washes or layers of colour are applied one over the other. The process used to be an extremely long one, with each glaze or layer of paint needing to dry completely before the next could be applied. Today, with the advent of relatively fast-drying alkyd mediums, the process can be carried out much more quickly.

Although traditional glazing techniques are now seldom used, the principle of working over a tonal underpainting with thin applications of colour, which are then modified using glazes, has been adapted over the years and is now common practice. You can also apply glazes to images painted using other methods, such as impasto (see pages 68–77). However, you must always apply the fat-over-lean rule (see page 22) and mix the glazes using a glazing medium that will remain flexible over the less flexible underpainting.

Using glazes

As you apply each coloured glaze, the colour density becomes greater and correspondingly darker. For this reason, you paint the traditional grisaille in a high key. This means that the darkest tone, if seen on a full tonal scale from white to black, should be no darker than a mid-grey.

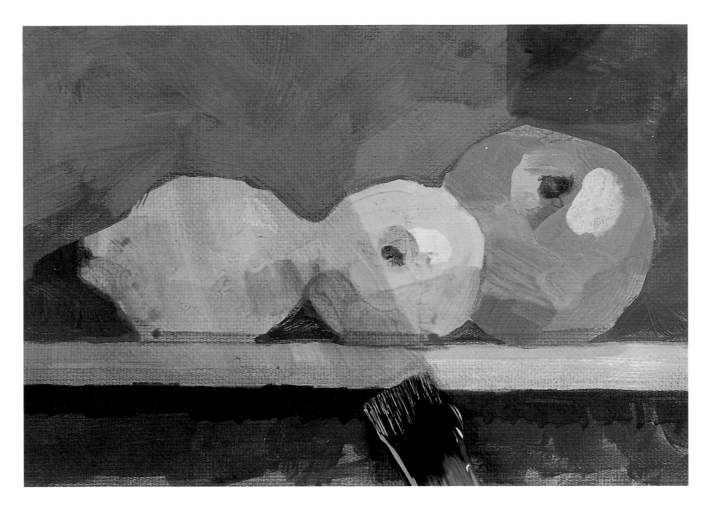

BRIGHTNESS OF COLOUR

Glazed colours often look brighter than those that have been mixed on the palette. Combine red and yellow to create orange and apply it to your surface. Now create a yellow underpainting, allow it to dry and apply a red glaze over the top. Notice how the second application is much brighter. The reason for this is that, when two colours are mixed together the purity of each is compromised and the resulting mixture is always darker. This also explains why it is better to work with paint colours that have been created from a single pigment whenever possible.

GLAZING TO CREATE COLOUR HARMONY

Another use of a glaze is to create an overall colour harmony, and the technique simply involves the overall application of a coloured glaze to the dry image. You need to choose the colour with care, however, as it can have a profound, and immediate, effect on the appearance and mood of the piece. You can change an overall colour cast to read as warmer or cooler or use a glaze to subdue harsh colour or tonal contrasts.

Deepening colour: The only thing you cannot do with a glaze is to make an image appear brighter, as a glazed colour will always slightly darken existing colours.

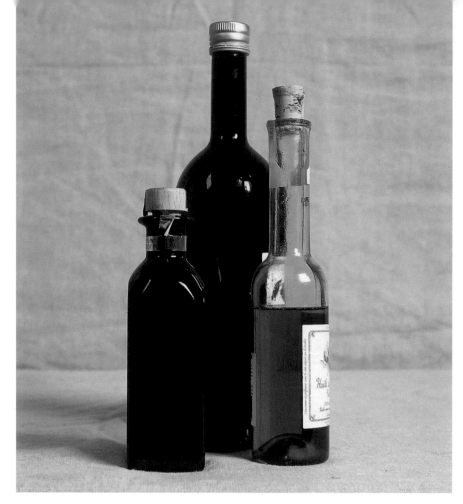

PAINTING THE BOTTLES

Three bottles are arranged in a group. The smooth, reflective surfaces provide the perfect subject for illustrating the glazing technique. The underpainting is made using oil paint and fast-drying alkyd medium, but the process can be speeded up by using acrylic paint, which will dry in minutes rather than hours. Alkyd painting medium is used in the mixes for the underpainting while glazing medium is used for steps 4 to 9.

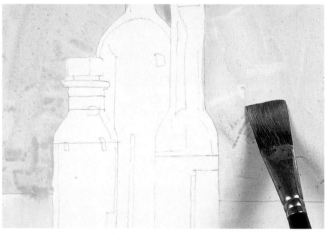

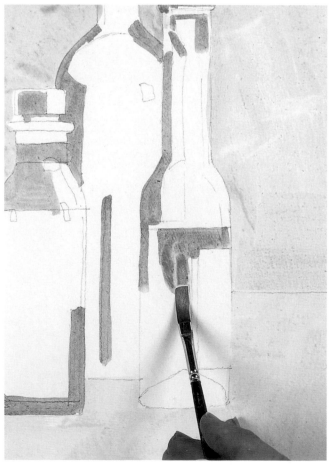

1 Start by drawing a light, relatively precise, pencil drawing before setting to work on the tonal underpainting. Mix a very light grey using ivory black and titanium white with added alkyd medium and, using the 2.5 cm (1 in) brush, block in the tone of the background, working carefully around the shape of the bottles. Lighten the mix slightly for the tablecloth.

2 Switch to the 6 mm (¼ in) brush. Using a slightly darker mix, carefully paint in the mid tones seen on the bottles, the reflections and the changes in tone where the liquid is. Mix these tones so that they are slightly lighter than in reality.

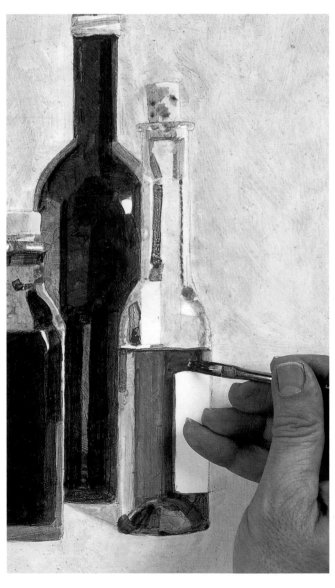

3 Darken the mixes and block in the darkest tones, working around any lighter areas of reflected colour or tone. Allow the white of the gesso ground to show through to represent highlights. Once the tonal underpainting is finished, leave it to dry. If you have used quick-drying alkyd medium and the painting is placed in a warm environment, it could be sufficiently dry in 24–48 hours.

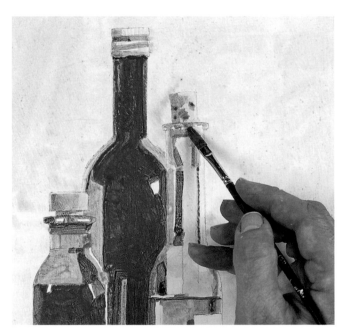

4 Now you can begin to apply the coloured glazes. Start by mixing a light ochre, using cadmium yellow, raw umber and a little cadmium red. Apply this to the cork stoppers and screw cap, using the 6 mm (¼ in) brush. Note how the tonal underpainting reads through the transparent glaze, describing the form.

5 Mix a deep orange using cadmium red and cadmium yellow, and use this to paint in the contents of the clear glass bottle on the right. Apply a viridian green and raw umber mix to the tall bottle in the centre and the smaller bottle on the left.

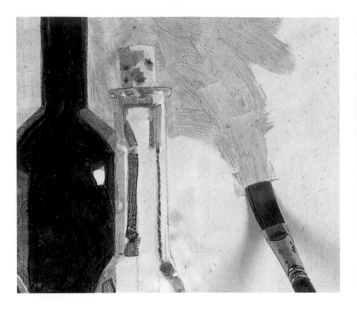

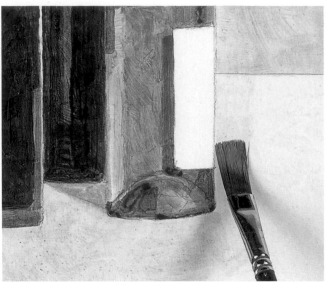

6 Mix a dull ochre glaze for the background. Use raw umber and cadmium yellow, and add a little cadmium red and ultramarine blue. Add a little titanium white, but use this sparingly to avoid making the mixture too opaque. Apply using the 12 mm (½ in) brush.

7 Use the same colour on the clear glass bottle, working around any white reflections. Use a lighter version of this mix to block in the cloth. Once completed, the image must be allowed to dry thoroughly, which will take anything from 24–48 hours, if placed in a warm environment.

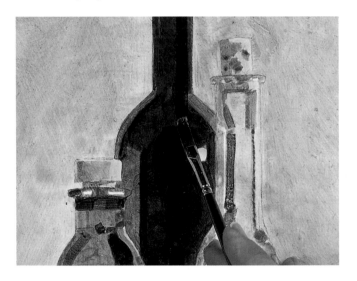

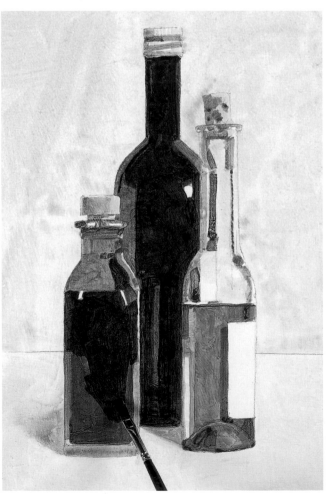

8 Check that the painting is dry before resuming work. Mix a deep, dark green using viridian green, ultramarine blue and raw umber, and repaint the dark green bottles using the 6 mm (¼ in) brush. Only paint the very darkest areas.

9 For the contents of the clear bottle, mix a deep orange using cadmium red and cadmium yellow into which you add a little raw umber.

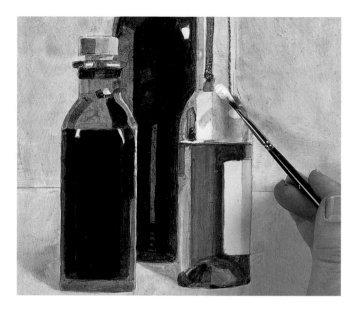

10 Use titanium white to carefully repaint any highlights on the bottles that you might have inadvertently covered with any coloured glazes.

11 The finished image demonstrates how the grisaille technique is employed to establish the tonal variations, while a series of thin glazes are used to build up the colour of the painting.

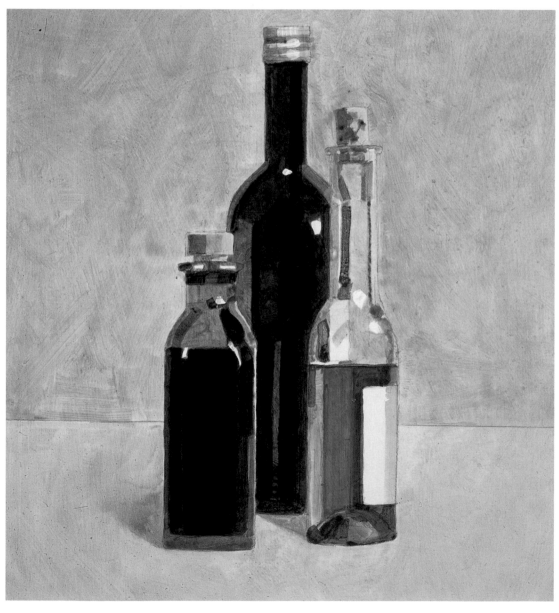

Step 6
blending

focus: three pears

Materials

25 x 30 cm (10 x 12 in) prepared
 canvas board
2B graphite pencil
6 mm (¼ in) flat synthetic-fibre brush
12 mm (½ in) flat synthetic-fibre brush
Small synthetic-fibre fan blender
Turpentine
Alkyd painting medium
The palette:
- *Titanium white*
- *Cadmium red*
- *Cadmium yellow light*
- *Cadmium yellow*
- *Ultramarine blue*
- *Raw umber*
- *Viridian green*
- *Ivory black*

The 'invention' of oil paint, during the early years of the Renaissance, changed the way in which artists worked and how they looked at things. It was introduced at a time when artists were becoming interested in 'illusion' and optical trickery, and sought to paint images with an almost lifelike quality. Oil paints, with their potential for blending and creating imperceptible transitions from one colour or tone to another, made this more easily achievable.

USING BLENDING

Light falling on an object describes its form. The side facing the light source is invariably brighter in tone and colour, while the side facing away from the light source is darker. The change from light to dark is often a smooth transition of tone and colour rather than an abrupt change, and blended paint allows you to show this. Furthermore, the extended drying time of oil paint allows you to achieve this in an unhurried and considered way, adding or removing paint and modifying the result until satisfied. Blending can be overdone, however, and can look surprisingly flat and uninspired. Remember that you are creating a painting, not a photograph, and it can be advantageous to allow the character and quality of the painted mark to show.

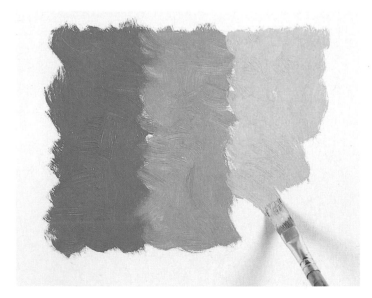

Preparing to blend: The two colours for blending are mixed to produce a third colour, which is then placed between them on the painting surface before the points at which they all join are blended. The paint is applied relatively loosely at this point.

ROUGH BLENDING

Blending two or more colours or tones together requires a degree of preparation. Mix the two different colours or tones on the palette and apply them to the painting, side by side. Now work over the point at which they join using a flat brush and multi-directional strokes, mixing the two different applications of paint together.

An alternative approach is to mix a third tone or colour, which is part way between the two original mixes. You can achieve this simply by mixing amounts of both together on the palette. Apply the third tone or colour at a point between the two original mixes and blend as above to work the three applications of paint into one another.

SMOOTH BLENDING

In order to create a very smooth transition from one colour or tone to another you simply take the same process a step further. Firstly, apply the paint and rough blend as above. Clean and dry the brush and rework the area using softer, more considered brushstrokes. Keep removing paint from the brush as you work, by wiping it onto a rag or paper towel, but do not rinse in solvent, as this will ruin the blended effect. Flat-bristle or soft-hair brushes are best used for smooth blending. Alternatively, use a fan blending brush designed for this very purpose but avoid using it for mixing paint on the palette as this can spoil its shape, and take extra care in removing paint from the brush so as to avoid build-up.

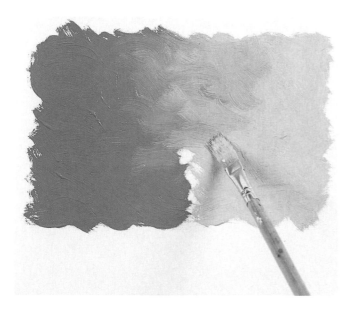

Rough blending: When blending, multi-directional brushstrokes result in a more satisfactory blend than brushstrokes that all move in the same direction.

Smooth blending: For smooth blending, rework the area and remove excess paint from the brush until you reach a satisfactory transition from one colour or tone to the next.

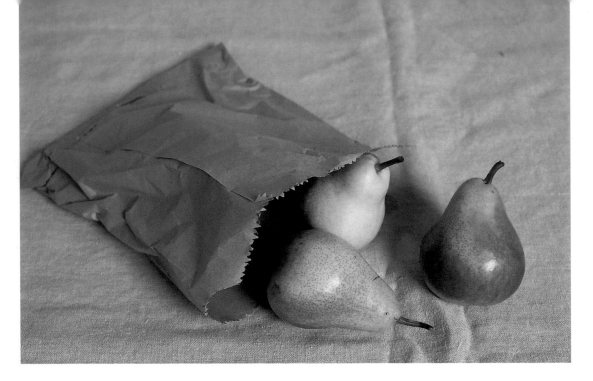

PAINTING THE THREE PEARS

Three pears spill from the bag in which they were bought, making a perfect still-life composition. The curved graceful forms of the pears contrast with the hard, crisp edges of the brown paper bag. Turpentine and alkyd painting medium are used for the mixes throughout.

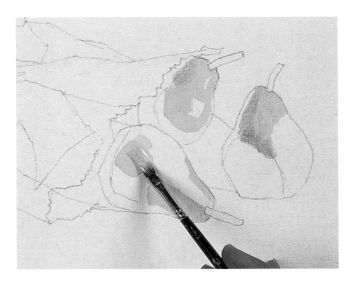

1 Draw in the shape and position of the pears and the bag using the 2B pencil. Keep the drawing simple and relatively light. Mix a bright green using viridian green and cadmium yellow light. Take a little of this and add titanium white to lighten and then a little raw umber to subdue it. Variations of this mix provide the basic green colour range for all three pears. Paint in the green of the pears using the 6 mm (¼ in) brush.

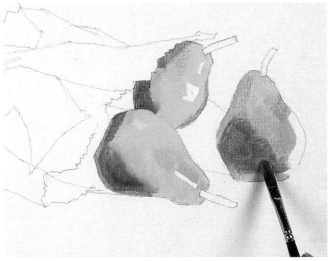

2 Add cadmium red and raw umber to a little of this base green and use this colour to add the red bloom to each pear. Work the paint up to and into the green, softening the point at which they join using a clean brush.

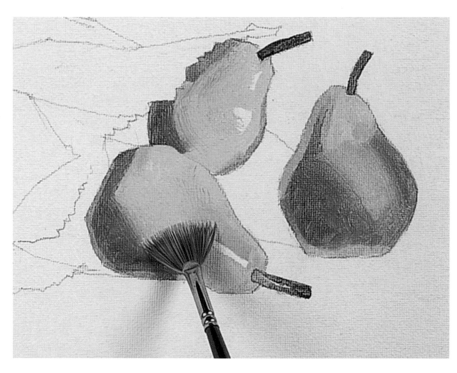

3 Carry out further blending, if needed, using the fan blender.

4 Return to the 6 mm (¼ in) brush. Make a light brown by mixing raw umber and cadmium yellow with a little cadmium red. Make this mix lighter or darker as required by using titanium white or ivory black and raw umber. Use variations of this mix to paint the paper bag, carefully taking each folded facet and crease in turn. Use a very dark mix for the inside of the bag.

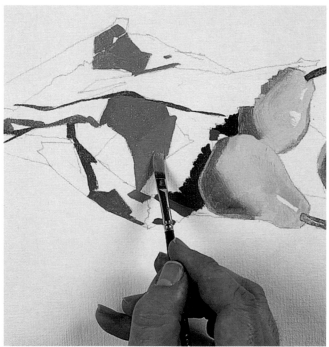

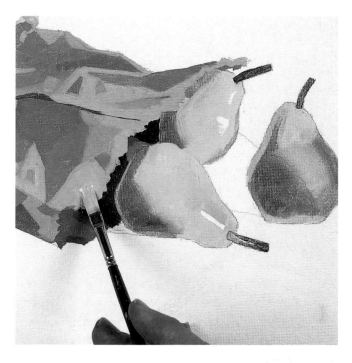

5 Add plenty of titanium white to the mix for the lighter passages, and continue until the bag is completely painted. Use the corner of the brush to paint the serrated edge of the open bag.

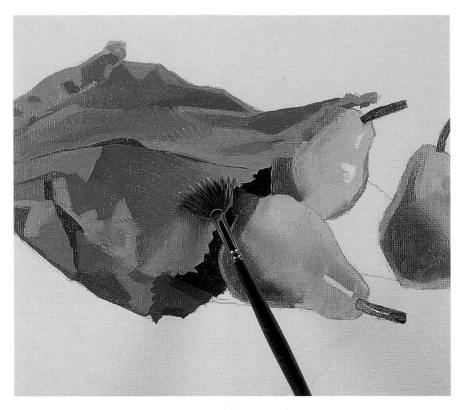

6 Use a clean fan blender to soften and blend together the join between the tones in those areas of the paper bag where the creases have less definition. Take care not to overdo this, or the creased and crumpled effect of the paper will be lost.

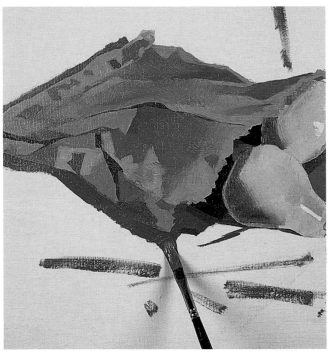

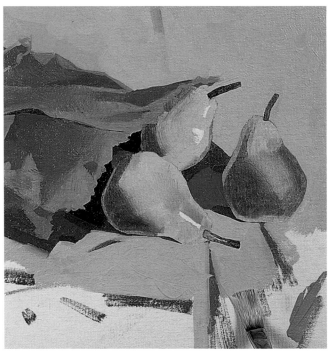

7 Mix a dark brown using raw umber with a little ultramarine blue. Add just a little titanium white and, with the 6 mm (¼ in) brush, paint in the shadow beneath and around the pears and the bag. Use a few simple brushmarks to render the shadows on the slightly crumpled cloth.

8 Make the colour for the tablecloth by adding plenty of titanium white to the brown mix, and paint using the slightly larger 12 mm (½ in) brush. Brush the colour freely over the dark brushmarks that represent the slight creases of the cloth, and use it carefully to work up to and around the painted pears and bag, redefining their shapes if needed.

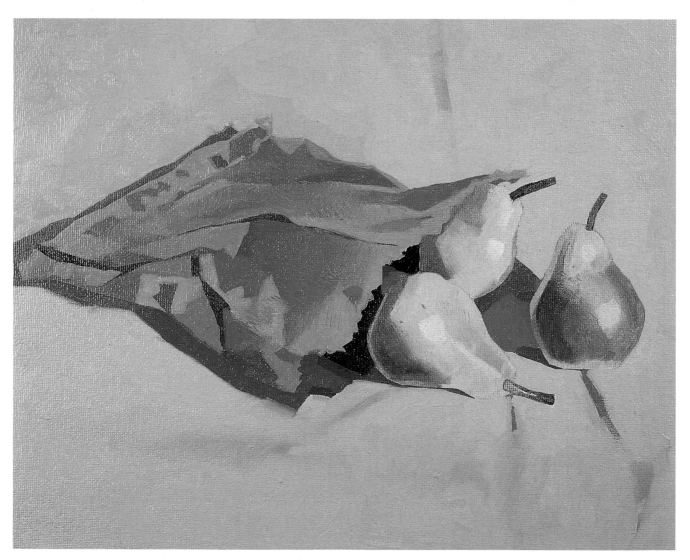

9 Use the smaller of the two brushes to paint in a few white highlights on the pears.

10 In this relatively simple exercise, the finished image demonstrates how the blending of colours and tones on the painting surface can result in a more lifelike representation of the subject.

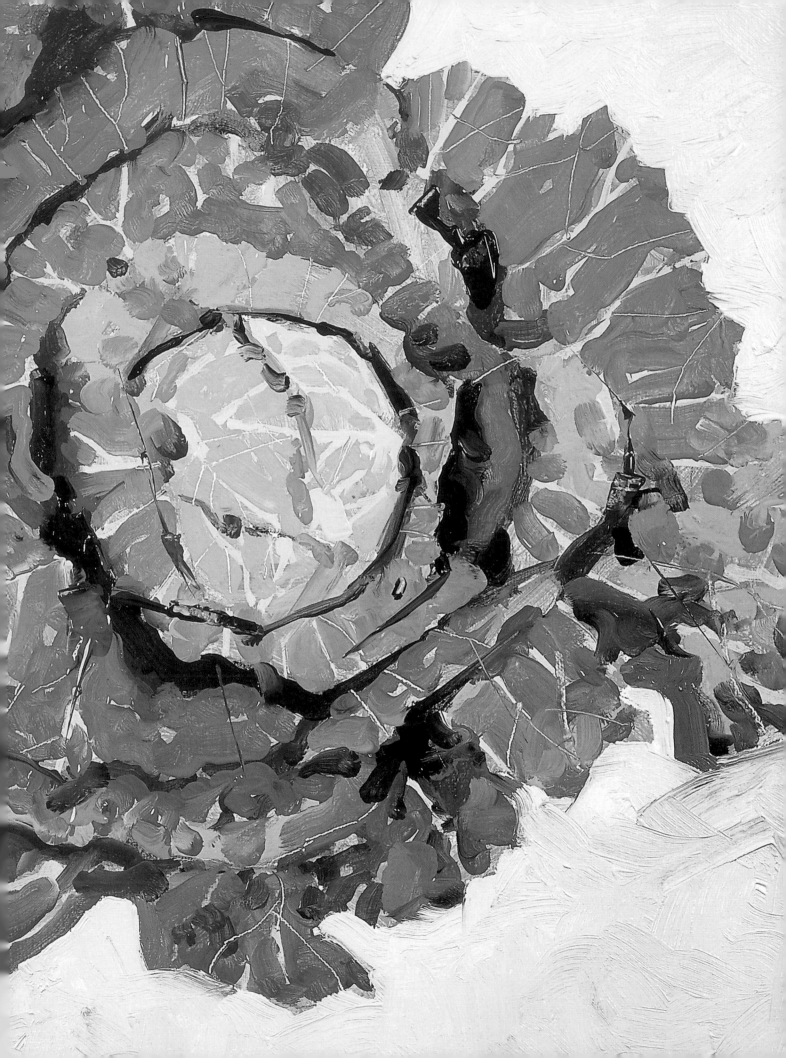

Step 7
impasto

focus: cabbage

Materials

36 x 46 cm (14 x 18 in) prepared
 canvas board

Soft charcoal pencil

Fixative

6 mm (¼ in) flat synthetic-fibre brush

12 mm (½ in) flat bristle brush

Small trowel-shaped painting knife

Turpentine

Alkyd painting medium

The palette:

- *Titanium white*
- *Cadmium yellow light*
- *Ultramarine blue*
- *Pthalocyanine blue*
- *Raw umber*
- *Ivory black*

The Italian word *impasto* means dough and describes a technique using thick, heavy applications of paint that stand proud of the support. Paintings that have been made using impasto techniques have a tactile quality, which invites you to run your fingers over the painted surface once it is dry. Such pieces are wonderfully expressive works, retaining the marks made with the brush, painting knife or paint shaper when the paint was applied.

MIXING IMPASTO PAINT

Oil paint used straight from the tube for this technique can take a long time to dry and can wrinkle and crack. It can also use up paint very quickly. The answer is to combine the paint with a suitable painting medium. Do not add oily mediums, which will simply prolong the drying time. If you intend to create a work that uses only moderately thick paint, use a thick, gel-like, quick-drying alkyd medium. If, on the other hand, you require very thick applications of paint, use a heavy-bodied impasto medium that contains silica.

SUITABLE PAINTING SURFACES

Always work on a surface that is substantial enough and has a medium or course texture. There are several reasons for this: the thick paint, on even a moderately sized impasto work, can be quite heavy and may cause sagging; impasto paint is often applied in a robust or rough manner which could damage a delicate surface; the rougher texture helps the thick paint adhere to the support; and the pronounced texture of the surface will inevitably read through in places, so contributing to the overall effect of the painting.

APPLYING THE PAINT

You can begin an impasto painting by first creating a drawing. Charcoal is an especially suitable medium for this. Work loosely to encourage direct applications of paint. If you wish, you can also make an underpainting using paint thinned with turpentine or another diluent, but no added oil. Allow the painting to stand for a while, so that the diluent content evaporates, before starting any impasto work. You can apply the paint using bristle brushes, painting knives and paint shapers. Many artists also use a number of other ways to apply the paint including bits of wood, rags, forks or even their fingers.

MAKING CORRECTIONS

You can easily make corrections by scraping off paint using a painting or palette knife. Either discard the paint or return it to the palette for reuse. Take care to keep your colours crisp and true and avoid overworking an area. A successful underdrawing or painting will lead the way for sure, precisely placed applications of paint. Remember, also, that you can scrape or scratch into the paint to create a wealth of linear marks and textural effects, known as sgraffito (see Adding detail and texture, page 47). Once the painting is finished, place it somewhere safe so that the surface remains untouched until it is completely dry.

Mixing impasto paint: A heavy-bodied impasto medium added to the paint will increase the bulk of the paint without altering the colour. It will also reduce the paint drying time.

Brushwork: Work directly, using sure, precise applications of paint. If you fuss too much, you will compromise the textural qualities inherent in a good impasto work.

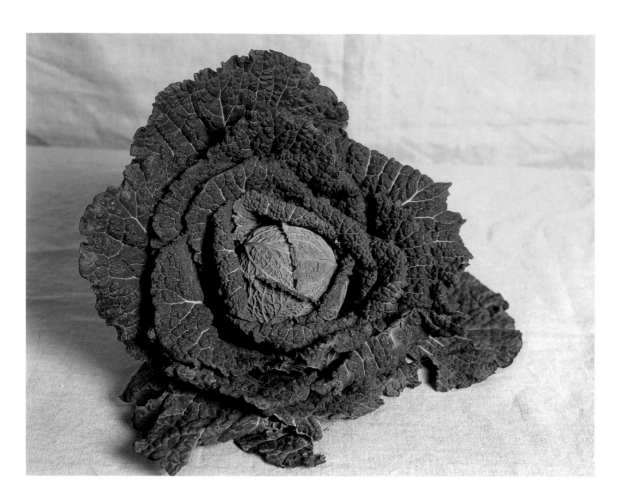

PAINTING THE CABBAGE

A cabbage was chosen for this project. Its strong textured leaves demand a bold approach, and impasto techniques enable the true sculptural quality and character of the vegetable to be described.

1 Begin by using the soft charcoal to describe the shape of the cabbage and the arrangement of the leaves around the central heart. Include the shape and position of the main dark shadows. Fix the drawing if you wish.

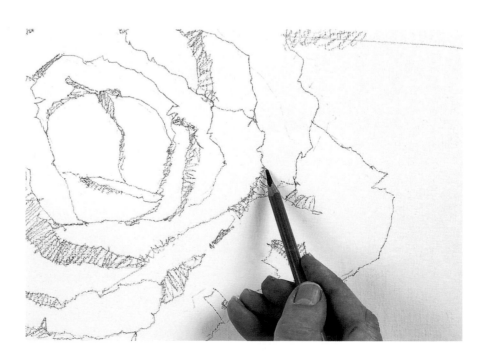

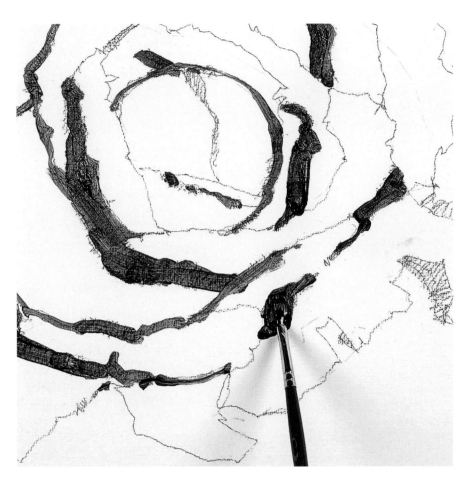

2 Work the underpainting. Mix a dark green using pthalocyanine blue, cadmium yellow light and raw umber. Use only turpentine to thin or dilute the paint. Subdue the colour using ivory black, and apply to those areas in deep shadow, using the 6 mm (¼ in) brush. Brush the paint out well: you do not want a thick build up yet and, since you will be applying another layer of paint over the top of this, you do not want this underpainted layer to be too wet.

3 Lighten the mix by adding more cadmium yellow light and titanium white, and use the colour to block in the overall colour of the cabbage with the 12 mm (½ in) brush. Scrub the paint on so that the brushmarks can be seen. Keep the paint relatively dry and apply in a thin layer.

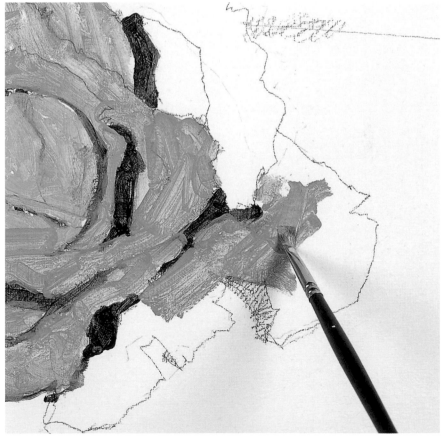

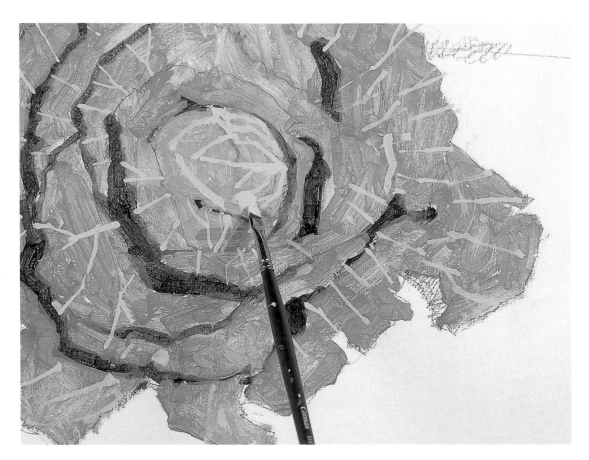

4 You are now ready to apply thicker applications of paint over the top of this underpainting. Lighten any mix that is left on the palette using titanium white and cadmium yellow light. You can also begin to add alkyd painting medium to your mixes now. Using deft, precise strokes of the brush, establish the light veins that run across the cabbage leaves. Keep the paintwork thick by loading the brush fully with paint before making a mark and avoid brushing the paint out too much.

5 Mix a brighter, mid-green using pthalocyanine blue, cadmium yellow light and a little raw umber, with ivory black to subdue it slightly. Add titanium white and, using directional strokes, begin to establish the lighter parts of each leaf with the 6 mm (¼ in) brush. Make precise, one-stroke brushmarks: if you scrub, or overwork, the paint you will pick up any previously applied paint that is still wet.

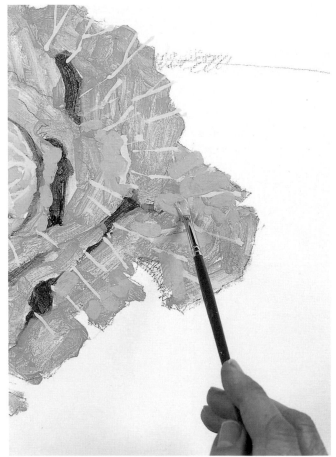

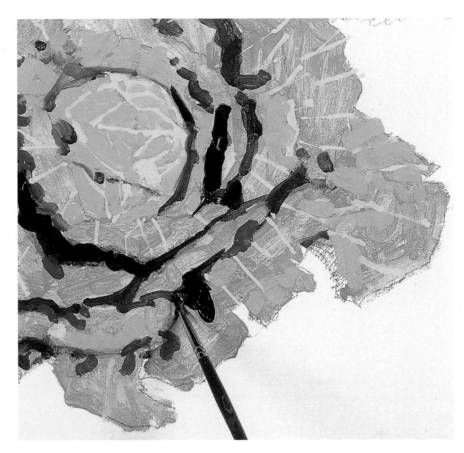

6 Now establish the darker tones. Mix a dark green using pthalocyanine blue, cadmium yellow light, raw umber and ivory black. With precise, deft strokes of the brush, work around each of the leaves in turn.

7 Lighten the dark green mix slightly by adding more cadmium yellow light and a little titanium white, and establish the rest of the colour on each leaf. Again, use precise brushstrokes and plenty of paint. Allow the lighter underpainting to show through in places, which will help describe the uneven texture of the leaves.

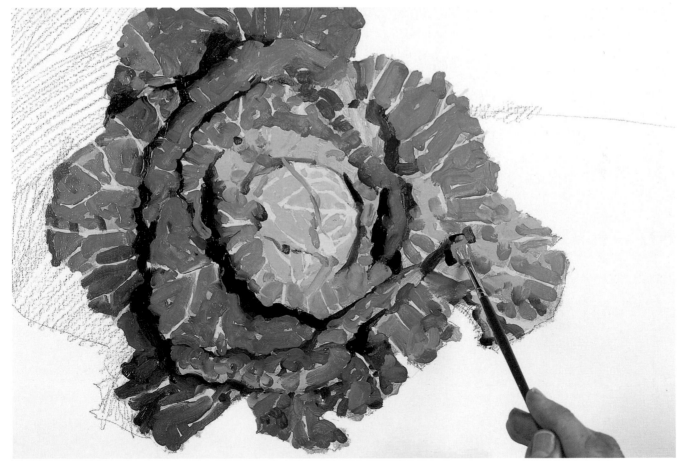

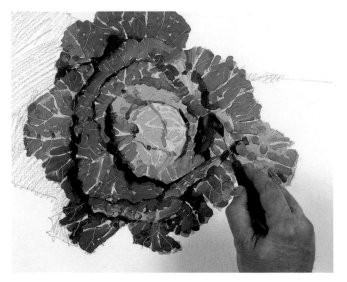

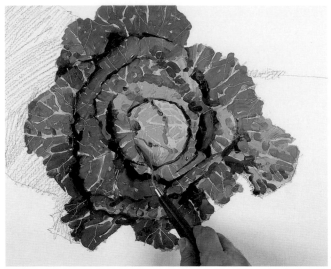

8 The paintwork should now look thick and juicy. You can work into areas by adding more paint, but beware of overdoing the brushwork or you will loose the definition and crispness that you have achieved. Use the point of the painting knife to draw into the wet paint, marking the very fine light veins that can be seen running across each leaf.

9 Use the edge of the same knife to apply crisp lines of dark paint to the leaves. Pick up a little dark-green paint using the edge of the knife, place the knife in position and make a precise stroke to leave a line of paint behind. Practise making these marks on a sheet of newspaper before committing yourself to making them on the painting itself.

10 The cabbage, although looking like a cabbage, appears to be floating in a white space and needs to be anchored firmly to its background. Mix raw umber and titanium white, with a little ultramarine blue. Use this colour to paint in the shadow on the left of the cabbage with the 12 mm (½ in) brush. Apply plenty of stiff, thick paint using short, fluid, multi-directional brushstrokes. Carefully work up to the cabbage leaves using the background paint to redraw the very edge of the leaves as required.

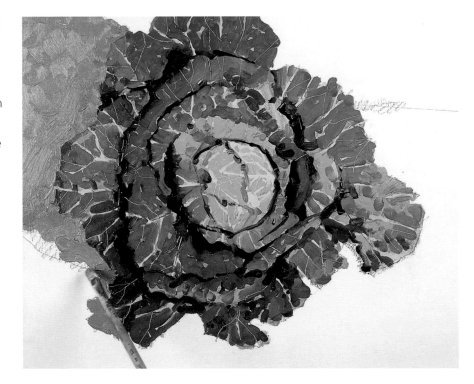

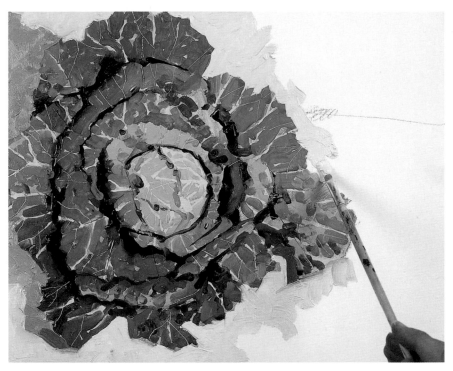

11 Lighten the mix using titanium white. Using the same brush as before, use multi-directional strokes to block in the rest of the background. Work up to the leaf shape as you go, redrawing the outline as required.

12 The finished image shows how the impasto technique can be used to great effect when the texture and surface characteristics of a subject are of equal importance to the artist as the colours and tones.

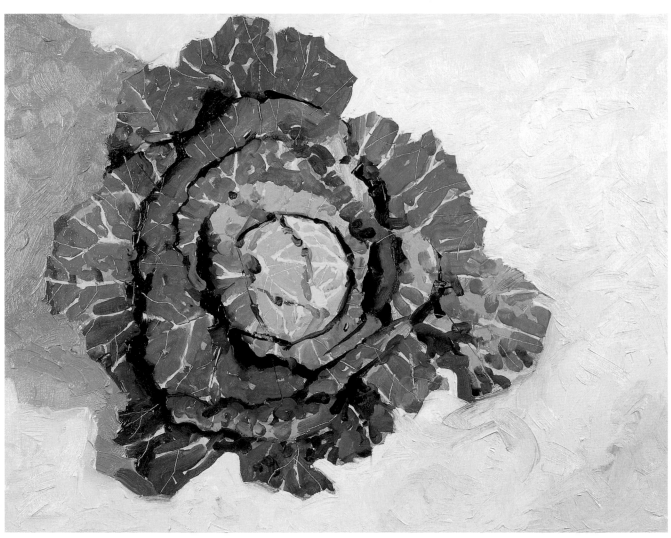

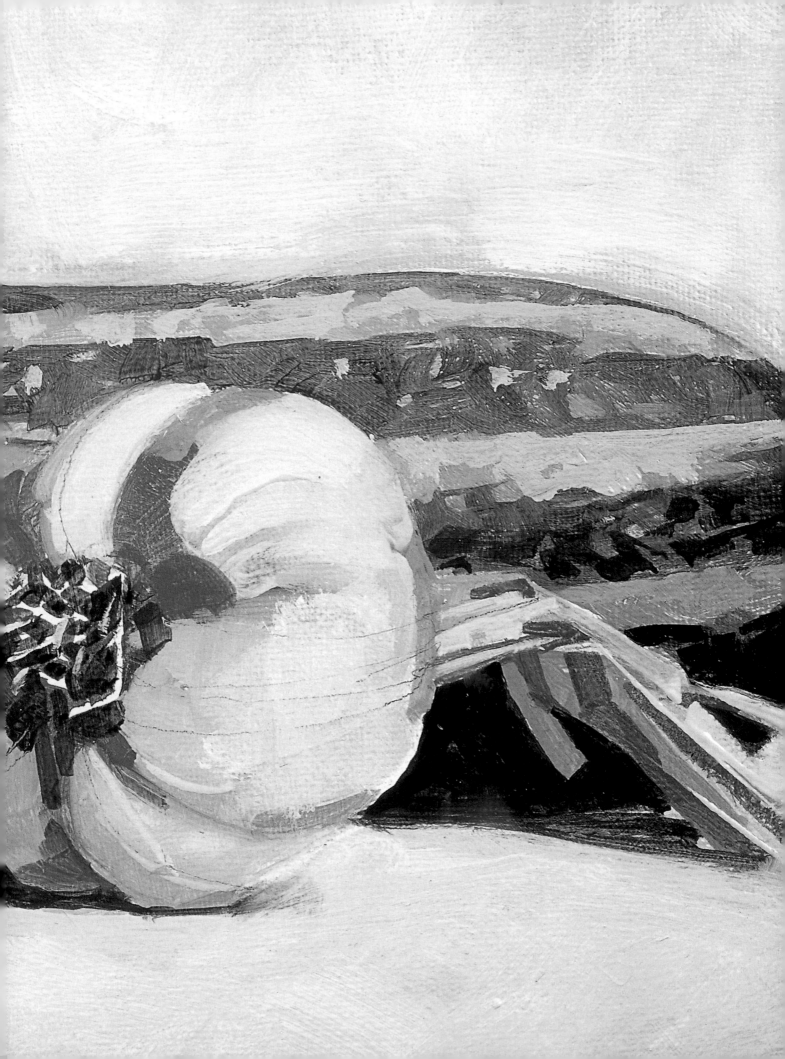

Step 8
special
techniques

focus: marrow and garlic

Materials

25 x 35 cm (10 x 14 in) prepared
 canvas board
Hard charcoal pencil
Fixative
6 mm (¼ in) flat synthetic-fibre brush
6 mm (¼ in) flat bristle brush
12 mm (½ in) flat bristle brush
2.5 cm (1 in) flat bristle brush
Turpentine
Alkyd painting medium
The palette:
• *Titanium white*
• *Cadmium red*
• *Cadmium yellow light*
• *Cadmium yellow*
• *Ultramarine blue*
• *Pthalocyanine blue*
• *Raw umber*
• *Ivory black*

The methods discussed here offer three different ways of applying paint, each rendering an effect that is difficult to achieve by other means. All are easy to use, although the effects achieved by optical mixing take a little time and patience.

SCUMBLING

For this technique you apply the paint in such a way that the paint layer or application underneath shows through in rough, irregular patches. Apply the paint using a stiff bristle brush and a brusque scrubbing, stippling, dabbing motion, or by rolling the brush over the support in a relatively haphazard way. You can also achieve a scumble using a rag or sponge. The paint used in scumbling techniques is usually of a stiff, 'dry' consistency although you can also use thinner, more fluid mixes of paint, taking care not to cover an area too thoroughly. Scumbling serves several purposes: you can use it to enliven a dull, flat area of paint; to represent textured surfaces; and to render the effects of dappled light. You can apply several scumbled layers, one over the other, but you must allow each layer to dry before applying the next.

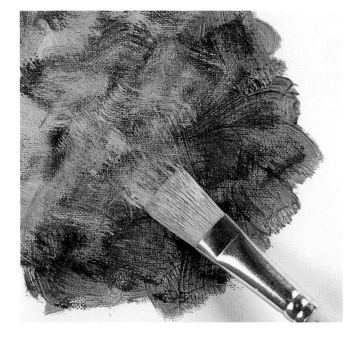

Scumbling: Light colours can be scumbled over dark, and cool colours over warm. Colours that are similar in hue can be scumbled over one another, as can bright colours over dull ones.

Broken colour: Areas of broken colour are those in which one, two or more applications of paint are made in succession, but are not blended with each other.

Optical mixing: Also known as pointillism, the optical-mixing technique takes time to do properly but is strangely satisfying to execute.

BROKEN COLOUR

While scumbling achieves a 'broken-colour' effect, the term usually refers to paint applied in small separate strokes that are not blended together. This is an important technique when working alla prima (see pages 44–51). Mixing the paint to a creamy consistency, you should keep the colours clean and bright, using direct brushwork and fluid, directional strokes that work around or follow the form of the object being painted. Paint applied in this way maintains a fresh, bright appearance and creates a jewel-like feel. Colour effects and transitions are achieved not only on the paint surface itself, but also in the eye of the viewer, as different areas of 'broken' colour appear to fuse together when viewed from a distance.

OPTICAL MIXING

The effect of pure colours fusing, or 'optically' mixing in the eye, is the central idea behind pointillism. Here, you place small dots or blobs of relatively pure hues in close proximity to one another. Like broken colours (see above) these dots seem to fuse together when viewed from a distance. You build up the small blobs or dots of colour steadily in layers: in order for each application of colour to remain absolutely 'pure', you allow one colour to dry before applying the next.

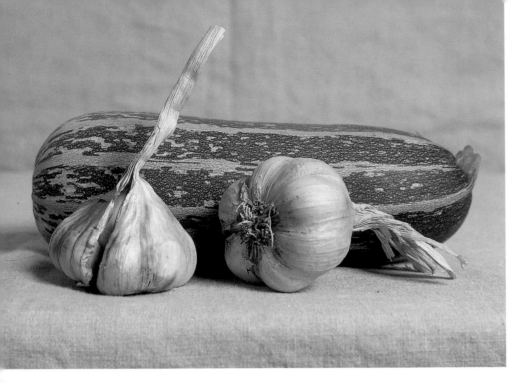

PAINTING THE MARROW AND GARLIC

The broken pattern on the marrow skin and the linear surfaces of the garlic provide an opportunity to explore scumbling and broken-colour techniques. Broken colour can be made wet into wet, but scumbling requires patience as it needs to be done on a dry or near-dry surface. Turpentine and alkyd painting medium are used in the mixes throughout.

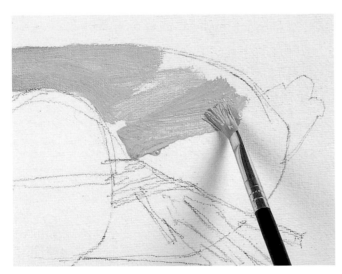

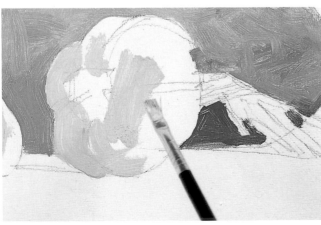

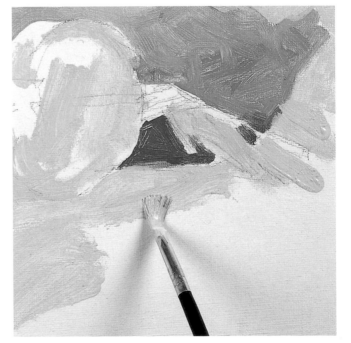

1 Establish your composition using a hard charcoal pencil, which you can fix prior to painting, if required. Mix a bright green using alkyd painting medium, pthalocyanine blue, cadmium yellow light and raw umber. Lighten this by adding titanium white to create a pale green. Use the 6 mm (¼ in) bristle brush to scrub this onto the marrow. Gradually darken the mix around the base and stalk end of the marrow.

2 Mix raw umber, a little cadmium red, cadmium yellow and titanium white to create a pale ochre and apply as the base colour for the two bulbs of garlic.

3 Make the dull beige of the background by mixing raw umber with plenty of titanium white. As before, loosely scrub this over the whole of the area surrounding the three main objects in your painting.

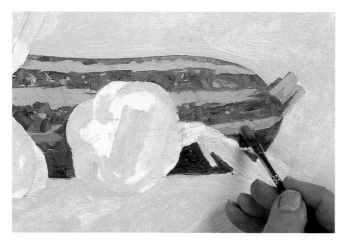

4 Mix a darker, brighter green, again using pthalocyanine blue, cadmium yellow light and raw umber. Use this colour, with the 6 mm (¼ in) synthetic-fibre brush, to paint in the dark stripes on the marrow. You will be working into thin, wet paint so use very direct brushwork and do not be tempted to scrub the paint on, as it will simply mix with the previously applied layer. Now darken the green mix using ivory black, and use to paint in the stripes that are in shadow. Add a little cadmium yellow light and titanium white to create a slightly more acidic green, and work this into the lighter pattern.

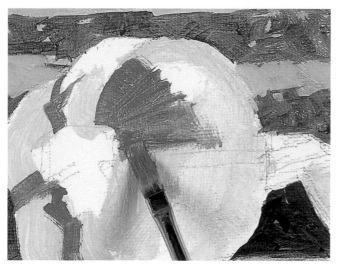

5 Mix a dark ochre colour, using raw umber and cadmium yellow to which you add a little cadmium red. Add titanium white, then a little black to subdue the colour's intensity. Use this mix to paint in the dark areas on the garlic bulbs. Lighten or darken this mix as necessary using white or black, and paint in the various tones and colours that give the garlic bulbs form.

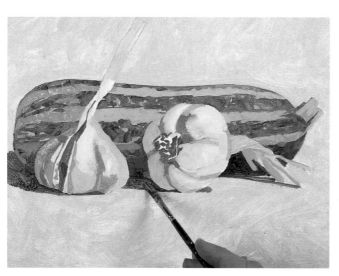

6 Still using the 6 mm (¼ in) synthetic-fibre brush, add the shadow beneath the marrow and the garlic using a mix made from raw umber and ultramarine blue.

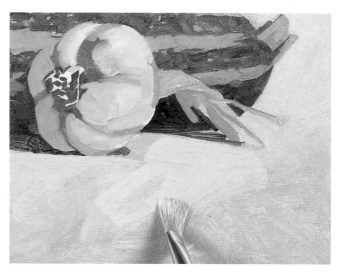

7 Consolidate the background by using the same mix as in step 3, loosely working over it using a 2.5 cm (1 in) bristle brush. Leave your painting to dry. The fast-drying alkyd medium should allow this to happen in about 24 hours if the painting is placed in a warm environment.

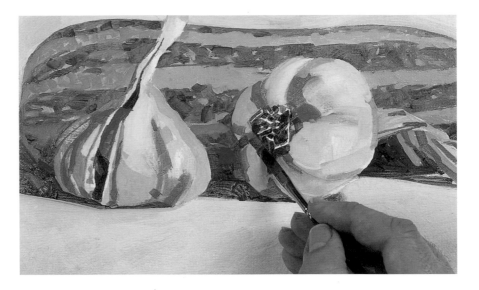

8 Once dry, you can resume work. Mix a dark ochre using raw umber, a little cadmium yellow and a touch of cadmium red. Use the 6 mm (¼ in) synthetic-fibre brush to paint in the darks on the garlic bulbs. Use the very end of the brush to create the lines on the dry stem and the tangle of dry roots at the base of the bulb.

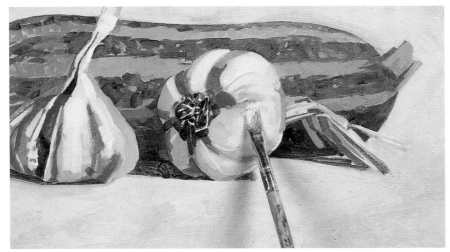

9 Add plenty of titanium white to this mix, but very little painting medium. Use this dry mix, and the very end of the brush, to create sharp textural lines on the dry garlic stems. Then, using the 12 mm (½ in) bristle brush, scumble over the lighter side of each garlic bulb using the same colour.

10 Mix a dark green using pthalocyanine blue, cadmium yellow light, a little raw umber and ivory black. Paint this onto the darker pattern on the marrow, creating a broken-colour effect using the 6 mm (¼ in) synthetic-fibre brush. Mix the same green again, this time making it much lighter by omitting the ivory black and adding more titanium white. Now use the broken-colour effect on the lighter patterned areas, overlapping dark-patterned areas with dabs of light green as appropriate.

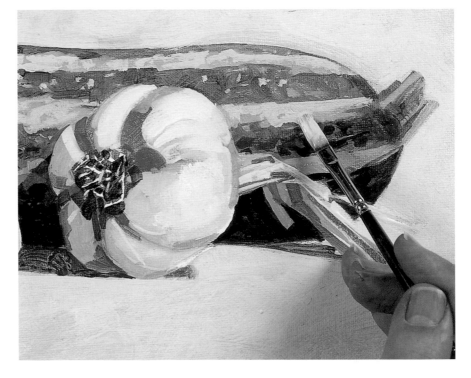

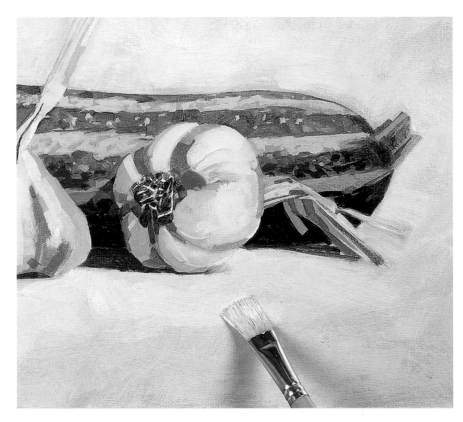

11 Remix and consolidate the background colour once more, using the larger 2.5 cm (1 in) bristle brush, making open, scumbled, brushstrokes to render a textural effect rather than a flat colour.

12 The finished image demonstrates how using the additional scumbling and broken-colour techniques can add a richness of colour and texture to a painting.

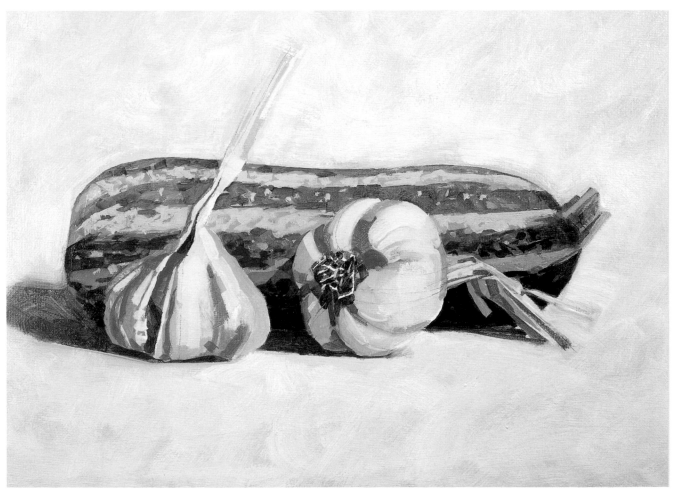

Step 9
composition

focus: arranging the elements

Materials
2 L-shaped pieces of card
2 bulldog clips

Composition concerns the design of your picture and how you organize all of the elements within it. A good composition persuades the viewer to move through the image in a predetermined way, focusing on those elements that the artist feels to be important. Any element of a picture can have an effect on its composition – colour, tone, shape, scale, texture and perspective. Various formulae have arisen over the years to help the artist plan out an image, and one such formula is the rule of thirds (see page 90).

FORMAT
Your first consideration when working out the arrangement is to decide on the format or shape of the image, because this will have a direct influence on your composition. There are three main formats:

> **Landscape:** a rectangle with the longest side running horizontally.
> **Portrait:** a rectangle with the longest side running vertically.
> **Square:** while the proportion of the two rectangular formats can be altered, the square format always remains square, no matter how large or small.

BALANCE
Balance in composition invariably means playing one element off against another. A small, brightly coloured object could balance a large, flat area of colour; two small objects might balance the impact of one large object; a heavy texture might be balanced with a smooth texture; or a positive shape might be balanced with a negative shape. By using this 'point and counterpoint' principle, you will find that the possibilities are endless.

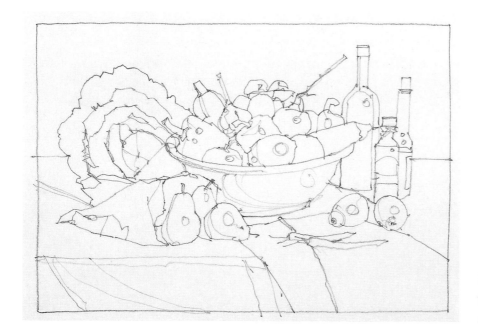

Landscape format: The landscape format persuades the eye to move across its area from side to side.

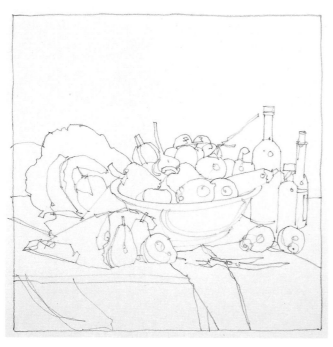

Square format: The square format is neutral. The eye tends to move from edge to edge, eventually spiralling in towards the centre.

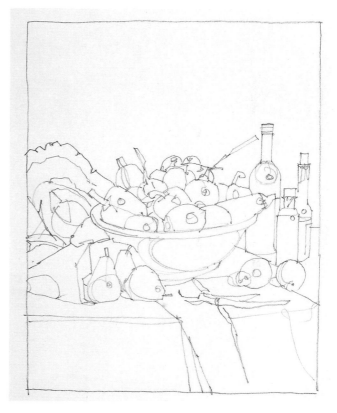

Portrait format: The portrait format persuades the eye to move vertically up and down across the area.

THE RULE OF THIRDS

This principle is based on a classical formula known as the 'golden section'. When using the rule of thirds you divide the picture area into thirds both horizontally and vertically. This division can be imagined or drawn onto the support using four correctly placed lines (see below). The theory is that, by placing important elements on or around the lines or the points at which they intersect, a pleasing composition results.

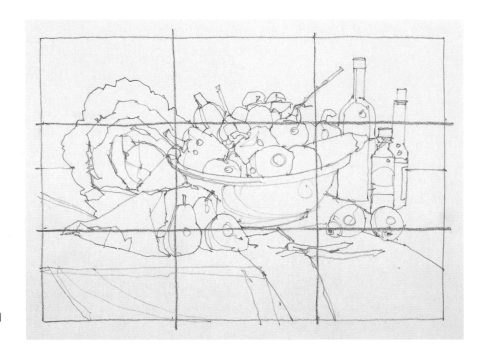

Deciding on the composition:
A landscape-format composition in which the picture area has been divided according to the rule of thirds.

Working out ideas: By making a number of sketched thumbnails before settling on your final composition, you can get a very good idea of what will work and what will not.

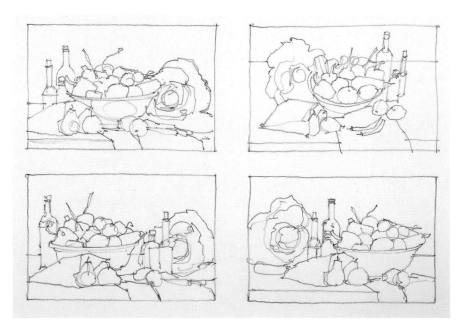

FOCAL POINT

All paintings should have at least one focal point – an element upon which you wish to focus attention. However, this should not be to the detriment of other elements within the image. In order to arrive at the focal point, you need to lead the eye on a predetermined path into and around the picture. You can do this in several ways, by connecting one element to another or by using a device known as a 'lead in'. Your lead in could be anything that literally leads the viewer in to the focal point – a log of wood, a road or a shaft of light.

BREAKING THE RULES

Many people have an instinctive sense of what makes a 'good' composition but, in some cases it pays to bend the rules a little. You can change an image dramatically by altering the viewpoint or the elements included in the arrangement, so try a number of different compositions before you begin work proper. Do this by making a series of simple, small sketches known as 'thumbnails' to work through a few possibilities.

MAKING A VIEWING FRAME

You can make a simple viewing frame by cutting two L-shaped pieces of card, and using them to 'frame' any format you like. Once you have a pleasing shape, simply hold the frame in place using two clips.

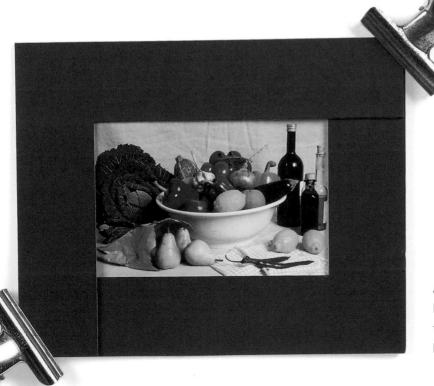

A simple viewing frame: You can hold the frame up and look through it to frame and check your composition before making any marks.

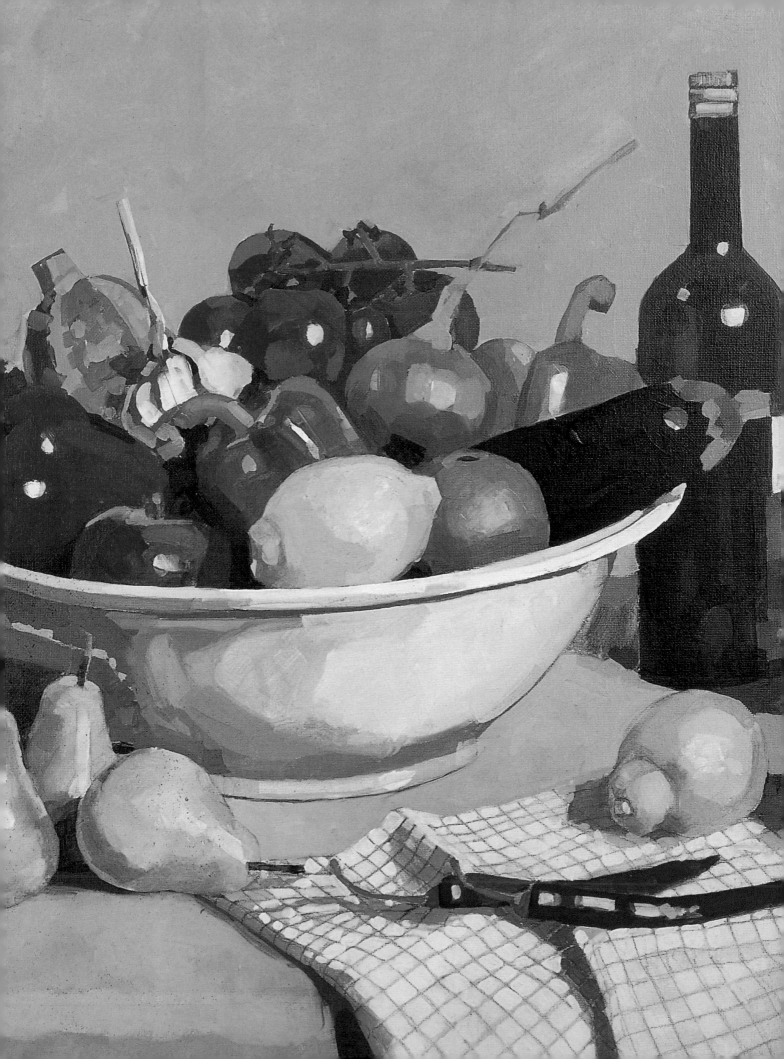

Step 10
bringing it all together

focus: still-life

Materials

60 x 75 cm (24 x 30 in) prepared
 canvas board
Medium charcoal pencil
Fixative
6 mm (¼ in) flat bristle brush
12 mm (½ in) flat bristle brush
3 mm (⅛ in) flat synthetic-fibre brush
6 mm (¼ in) flat synthetic-fibre brush
12 mm (½ in) flat synthetic-fibre brush
Turpentine
Alkyd painting medium
Small trowel-shaped painting knife
Red pastel pencil
The palette:

* *Titanium white*
* *Cadmium red*
* *Quinacridone red*
* *Cadmium yellow light*
* *Cadmium yellow*
* *Ultramarine blue*
* *Pthalocyanine blue*
* *Raw umber*
* *Burnt umber*
* *Viridian green*
* *Dioxazine purple*
* *Ivory black*

A still life has been constructed using articles bought on a typical food shopping trip. They have been chosen for their wide range of colours and textures. Arranged around a white bowl on a cloth-covered tabletop, the composition is constructed using the basic rule of thirds (see page 90). Nothing dominates: instead, attention moves in a loosely oval direction from one object to the next. The work is built up in three layers: a loose underpainting, a middle layer that consolidates the image and a final layer that reassesses and develops colour, tone and texture.

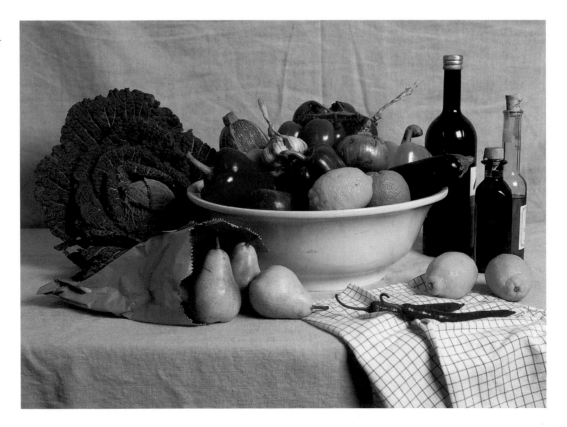

Stage 1: underpainting the composition

1 Using a sharp charcoal pencil, sketch in the composition on your canvas, using simple shapes and fluid strokes. Note that the composition is loosely based on the rule of thirds. Work lightly: holding the pencil high up the shaft will prevent you using too much pressure.

2 Rework the image once you have established the position of everything. Redraw and reposition each element in relation to its neighbour. As well as concentrating on the shape and scale of each object, draw in the shape and extent of any shadows, and the position of any major changes in tone and colour.

3 Step back to view your work. Your drawing can be as elaborate as you wish. The important thing is that you feel comfortable that enough information is included at this stage in order to guide you when it comes to applying the paint. If you wish, give the drawing a light coat of fixative to prevent the charcoal dust mixing with the paint.

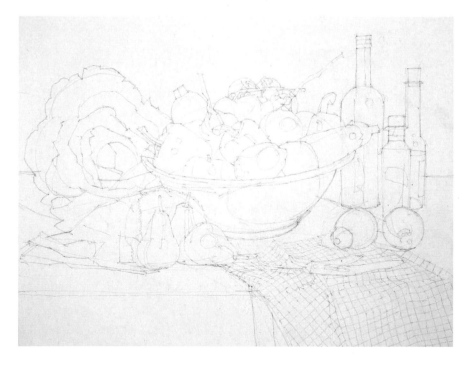

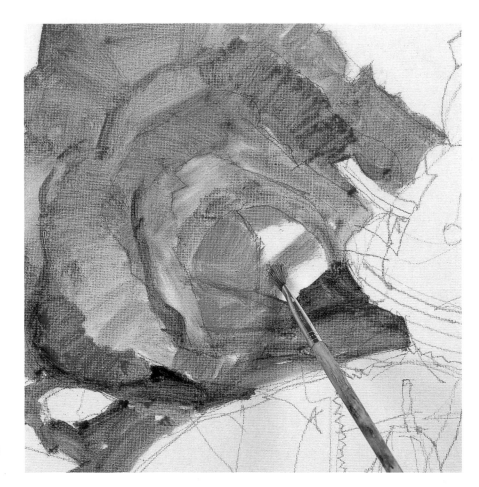

4 Now start on the underpainting. Keep your mixes 'thin' by adding plenty of diluent and a little alkyd medium. Begin by blocking in the cabbage using the 6 mm (¼ in) bristle brush and a range of greens made by mixing viridian green and cadmium yellow light, which you then modify using raw umber, ivory black and a little titanium white.

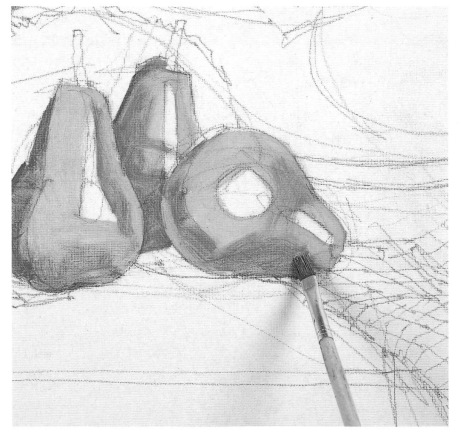

5 Move on to the pears spilling from the bag at the front of the composition, using cadmium yellow and titanium white together with a little green from the mixes used for the cabbage. Add a little cadmium red to warm up the mix for the reddish bloom on the skin. Leave the white canvas to show where there are highlights.

6 Paint in the paper bag with a range of light, ochre browns made using raw and burnt umber, cadmium yellow and titanium white. Add a little dioxazine purple to raw umber for the dark brown inside the bag. Work across the image, blocking in the fruit in the bowl and in front of the bottles. Make the red and orange mixes for the pepper using cadmium red, quinacridone red and cadmium yellow, darkened with a little green and raw umber. Use, also, the cabbage-green mixes; yellow and light pear-green mixes; and the brown paper-bag mixes for the onion.

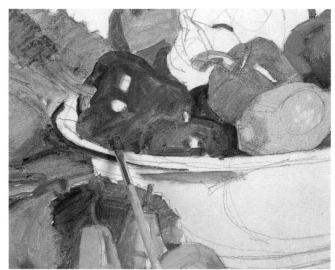

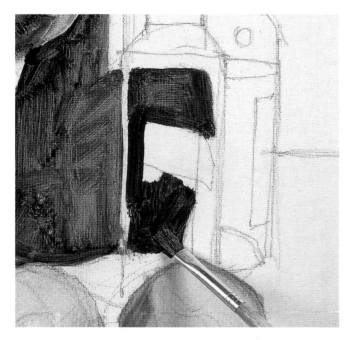

7 Use light grey mixes to block in the shadows on the white bowl, adding a little yellow under the rim of the bowl to suggest reflected colour from the pears. Paint the aubergine using a dark-violet mix made from dioxazine purple and burnt umber with a little added ivory black. Create a dark blue-green for the bottles by adding viridian green and a little pthalocyanine blue to the aubergine mix.

8 Use light yellow and ochre mixes, similar to those used on the bag, for the corks and cap on the bottles. For the background and the tabletop covering, mix a light beige using raw umber, cadmium yellow and a little dioxazine purple, then add titanium white. Block in these larger areas using the 12 mm (½ in) bristle brush. Use a slightly darker version of this mix for those areas that are in shadow.

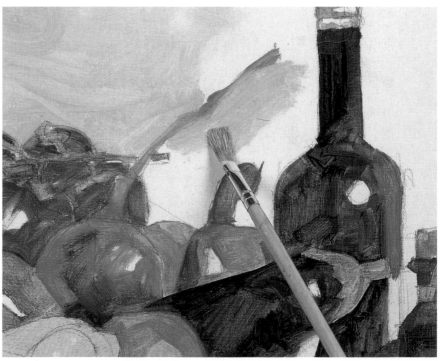

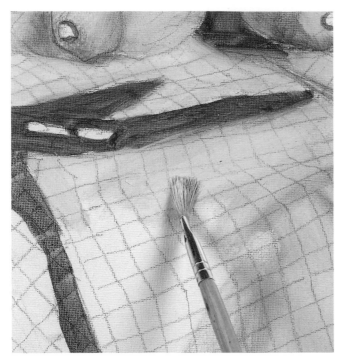

9 Lighten this last mix considerably with titanium white and, still using the 12 mm (½ in) bristle brush, block in the patterned napkin at the front of the image.

10 You have completed the underpainting. The image is now completely blocked in using thin applications of 'lean' paint. Both colour and tones are established and ready to be modified. Leave the painting to dry before proceeding – the addition of the fast-drying alkyd medium means that this should happen overnight.

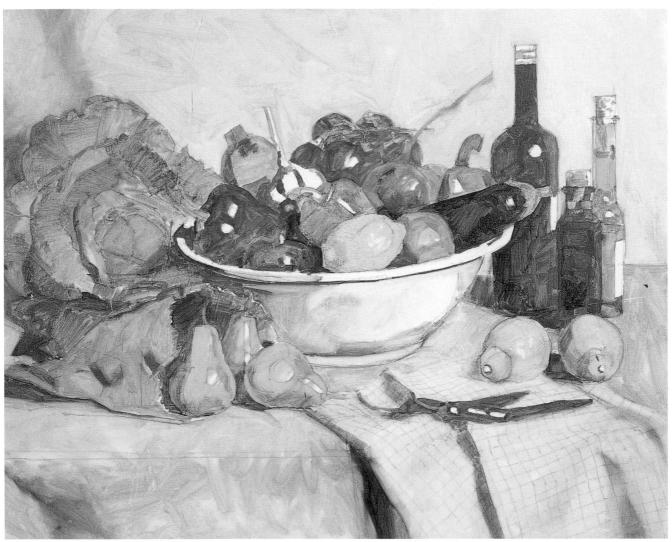

Stage 2: consolidating the image

11 Return to your painting, working across the image in roughly the same order as before. Begin by developing the colour of the cabbage, using similar mixes. Keep the paint to a creamy consistency this time, using alkyd medium and turpentine. Use the 6 mm (¼ in) synthetic-fibre brush to apply the paint. Allow the underpainting to show through in places if you wish.

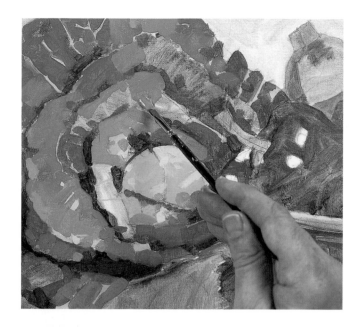

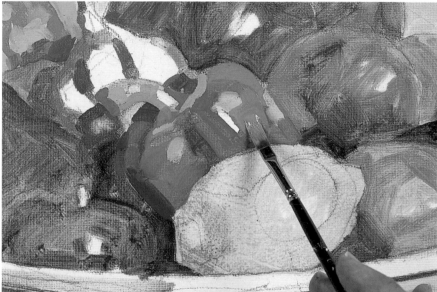

12 Adapt your green mixes for work on the marrow and the green pepper. Paint in the stalk of the tomatoes now, the stalks of the two red chillies at the front right of the image and the stalk of the aubergine.

13 Mix a range of light browns using raw and burnt umber, modified using cadmium yellow, a little cadmium red and plenty of titanium white. Use this colour to paint in the facets of the creased and crumpled paper bag with the 12 mm (½ in) synthetic-fibre brush. For the inside of the bag, mix dioxazine purple and ivory black with raw umber.

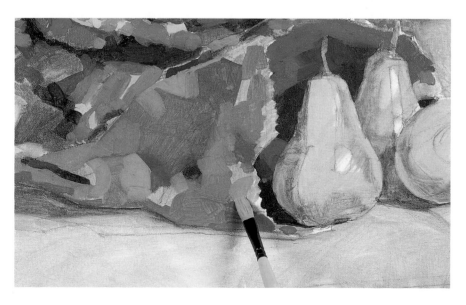

14 Return to the 6 mm (¼ in) synthetic-fibre brush. Use the same mixes to develop the onion. Then, working with a range of deep reds and oranges, strengthen the colour on the tomatoes and the red pepper. Add some light green to the deep-red apple at the front of the bowl.

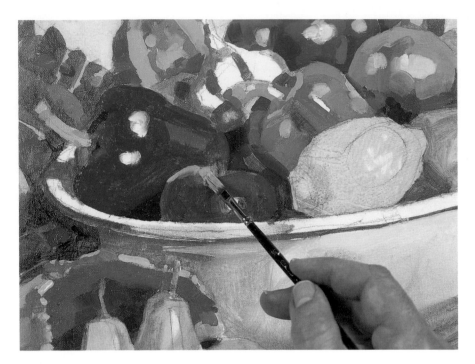

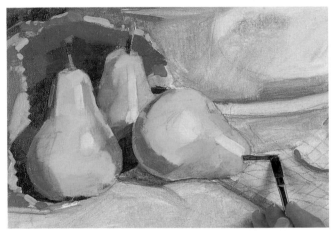

15 Consolidate the colours of the three pears with light yellow and green mixes. Add a little cadmium red and raw umber for the shadows. Add titanium white into the highlights and use raw umber for the stalks. Rework the lemons using bright-yellow mixes made using both yellows and a little cadmium red, modified with a little bright green. For the orange objects, use combinations of both reds and both yellows modified using a little dioxazine purple.

16 Make deep-violet mixes for the aubergine using dioxazine purple darkened with raw umber and modified using quinacridone red and pthalocyanine blue. Lighten the mixes by adding titanium white.

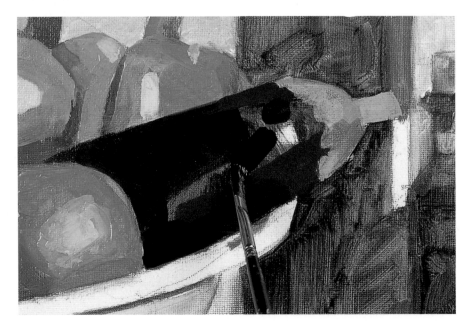

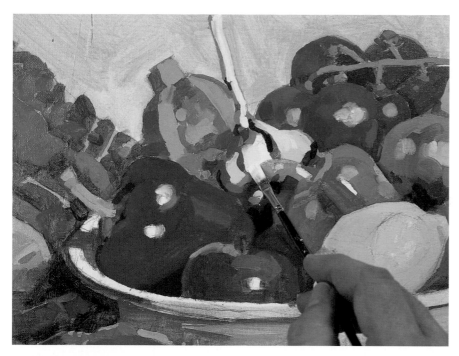

17 For the garlic, use subtle shades of titanium white modified using raw umber, cadmium yellow light dioxazine purple and ultramarine blue.

18 Stand back from your work again. See how the objects now appear to have a real solidity and the colours and tones are beginning to look correct. The brushwork remains crisp and interesting.

Stage 3: developing colour, tone and texture

19 Using the 3 mm (⅛ in) synthetic-fibre brush, develop the colour and detail on the bottle cap and corks. Use deep-yellow mixes for the cap but mix a more ochre yellow for the corks. Bring a little ochre down into the neck of the clear bottle.

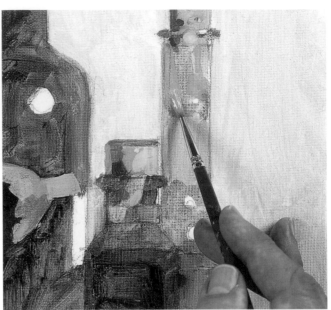

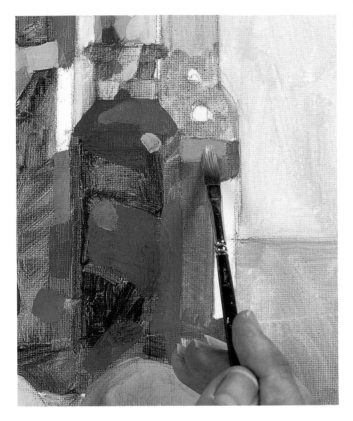

20 Make dark-green mixes from viridian green, raw umber and pthalocyanine blue, modified by adding cadmium yellow light. Use these, and the 6 mm (¼ in) synthetic-fibre brush, to suggest the lighter reflected colour on the two dark bottles. Repaint the amber contents of the lighter bottle using a mix made from cadmium red and cadmium yellow into which you add a little raw umber, then lighten using titanium white.

21 Using the 12 mm (½ in) synthetic-fibre brush, paint the darker colours on each bottle using mixes of viridian green, raw umber, pthalocyanine blue and ivory black. Work around the lighter reflections and highlights.

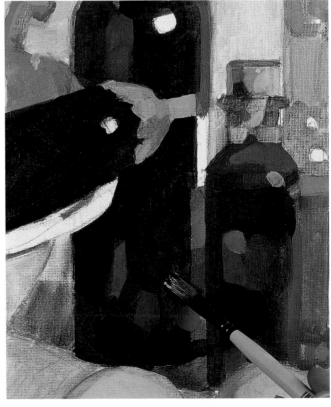

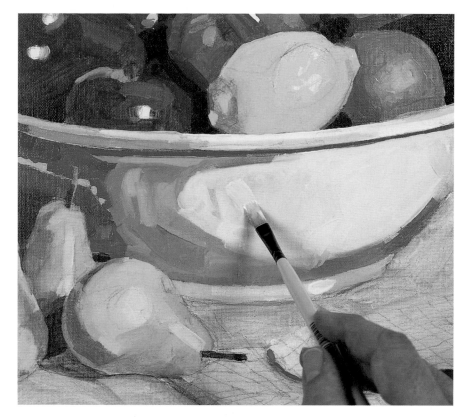

22 Turn your attention to the bowl. Paint the side that is in shadow and the area beneath the lip in a range of greys that are mixes of ivory black and titanium white, modified by adding a little raw umber and dioxazine purple. Add a little cadmium yellow light to this mix to create the patches of reflected colour and use a clean, pure titanium white for the side of the bowl facing the light.

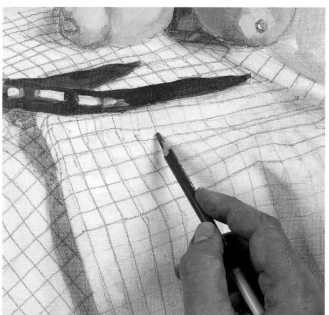

23 It can be difficult to draw fine lines with a brush, so use a red pastel pencil to draw in the pattern on the napkin. The effect is subtle and does not overpower.

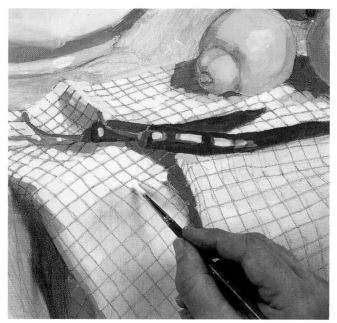

24 Return to the dark greys used for the bowl, and use them now to paint in the shadows on the napkin. Use titanium white to consolidate the overall colour and tone of the napkin. Apply the paint using the 3 mm (⅛ in) synthetic-fibre brush, working between the red pastel pencil lines.

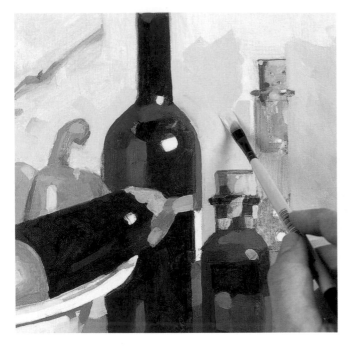

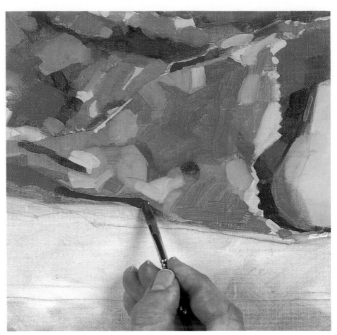

25 Remix the deep beige colour used for the background and repaint this using the 12 mm (½ in) synthetic-fibre brush. Redraw the shapes of your objects and tidy up their edges as you work, if it seems necessary.

26 Use the same mixture, darkened considerably by adding dioxazine purple, raw umber and a little ivory black, to paint in the shadows beneath the cabbage and the brown paper bag. Use the smaller brushes to paint the thin shadow beneath the bag.

27 Lighten the background mix by adding titanium white and, using the 12 mm (½ in) synthetic-fibre and open brushstrokes, work this colour over the tablecloth. Where the tablecloth falls over the front of the table, lighten the colour by adding more titanium white.

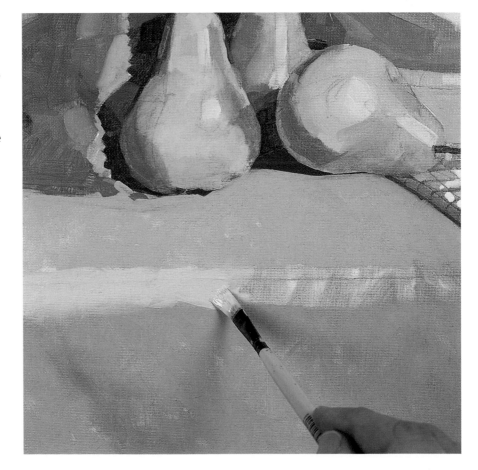

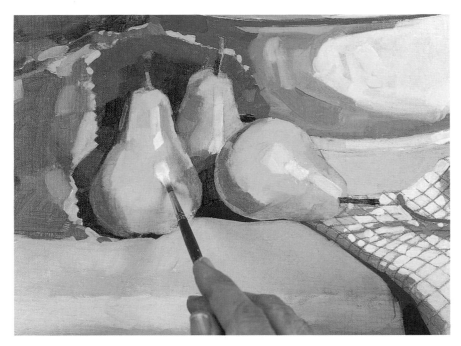

28 Reassess the highlights now. If they appear too bright and strident tone them down a little using the appropriate colours, applied with the smaller brushes.

29 Step back from your work again. The colours are looking richer, the forms have solidity and there is a real sense of depth. It is a good idea to leave the painting to dry overnight at this point.

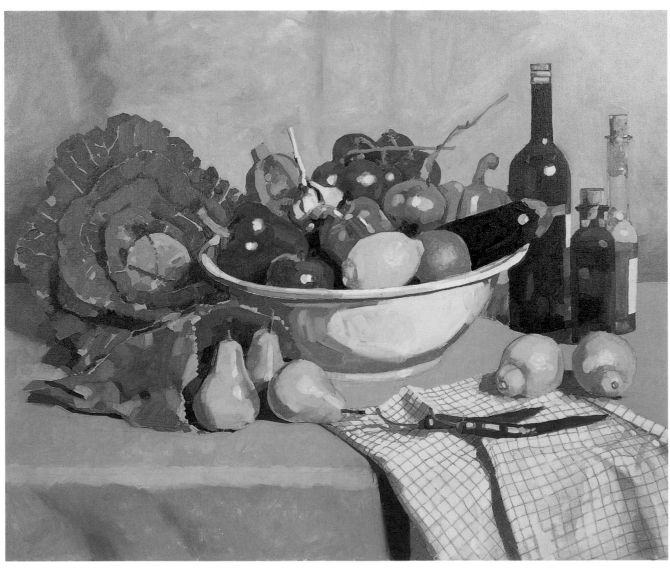

Stage 4: completing the picture

30 The textured surface of the cabbage requires more work. Remix a range of greens and darken the darks and lighten the lights of the cabbage using the 12 mm (½ in) synthetic-fibre brush. This has the effect of increasing the sense of form and the characteristic surface texture.

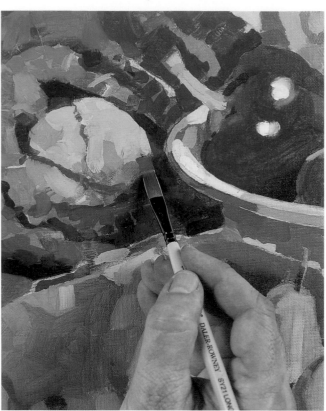

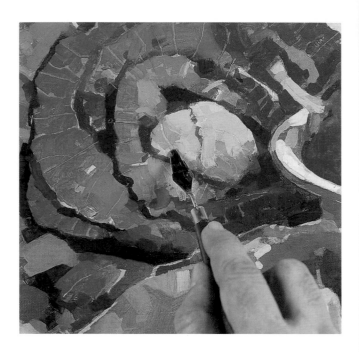

31 Render the veins that run across each leaf by using a sgraffito effect (see also, page 47). Use the palette knife to scratch through the wet paint applied in the previous step. You can achieve the same effect by using the pointed end of a wooden paintbrush or your fingernail.

32 Return to the 12 mm (½ in) synthetic-fibre brush. On those fruit that have a textured surface, like the lemons, apply the paint using a scumbled effect to represent the rough, pitted surface (see page 80).

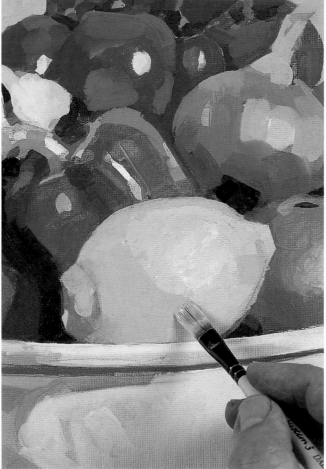

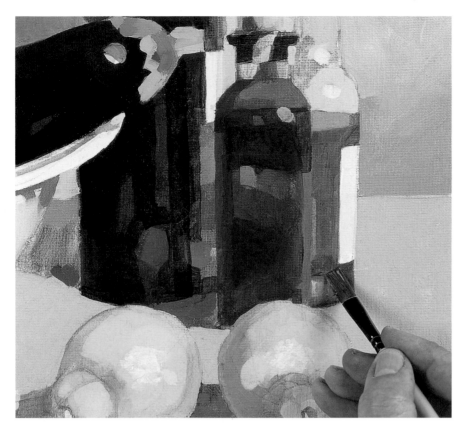

33 Darken the bottles. Mix a very dark green using viridian green, raw umber, pthalocyanine blue and ivory black. Use this as a thin glaze over the darkest reflections on the two dark bottles. Use a dark orange made from cadmium red, cadmium yellow and a little raw umber on the contents of the clear bottle.

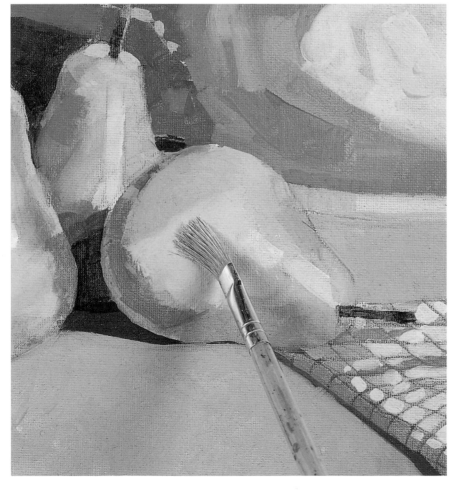

34 The tonal transitions from light to dark are still a little abrupt in places. Soften these by blending the paint, using loose but precise brushwork and the 6 mm (¼ in) bristle brush.

35 Intensify the reflected colour on the lighter fruit, especially the lemons, using a little glazed colour.

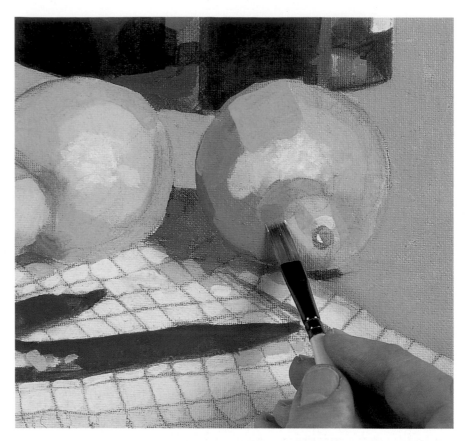

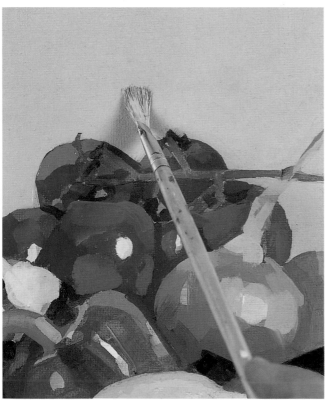

36 Repaint the background, using the 12 mm (½ in) bristle brush, making open brushstrokes that allow the previous colour to show through in places.

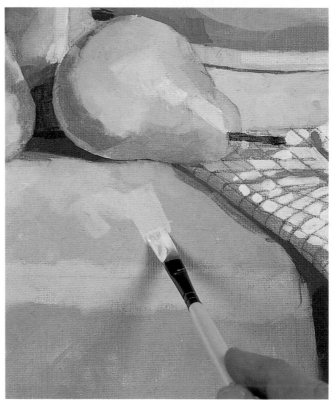

37 Lighten the mix and apply the same treatment to the tablecloth using the 12 mm (½ in) synthetic-fibre brush and multi-directional strokes.

38 In completing the painting, you have used the majority of techniques demonstrated in the previous steps of the book. In addition to settling on a workable composition, you have established shape, tone and colour at an early stage, and have built up the colour in stages. As the painting progressed you used a range of techniques – including blending, scumbling and glazing – to achieve the desired effect.

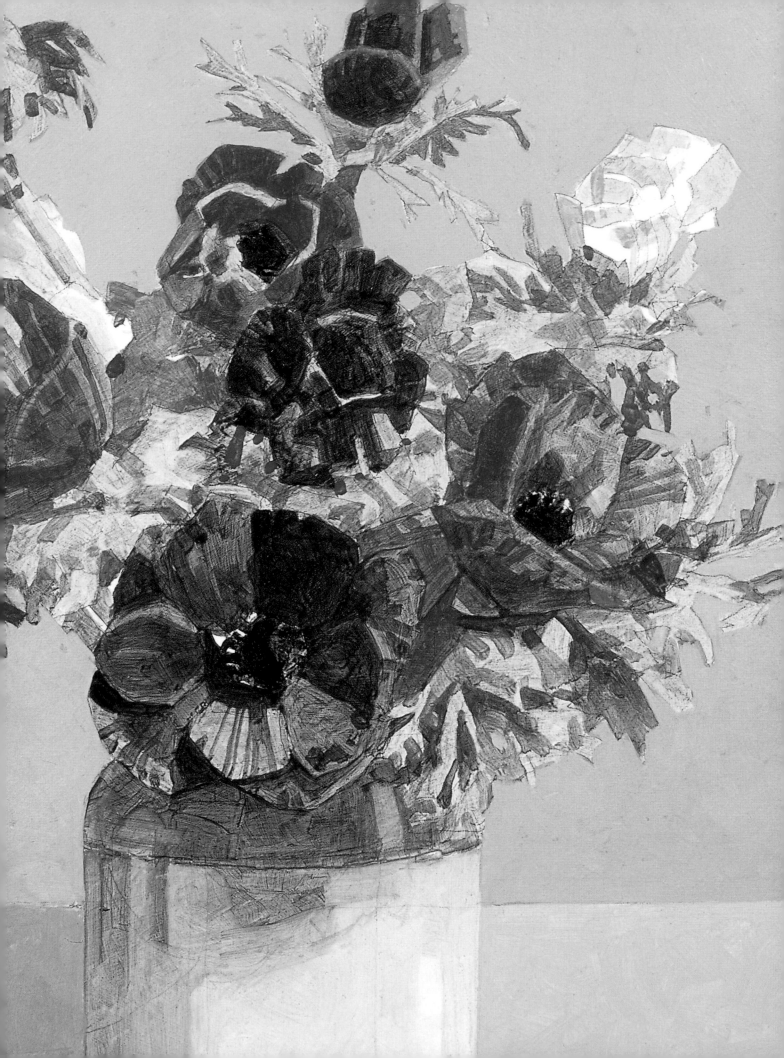

taking it a step further

bright anemones and landscape

focus: bright anemones

Materials

50 x 50 cm (20 x 20 in) MDF board
 prepared with gesso
2B graphite pencil
Eraser
Fixative
3 mm (⅛ in) flat synthetic-fibre brush
6 mm (¼ in) flat synthetic-fibre brush
12 mm (½ in) flat synthetic-fibre brush
18 mm (¾ in) flat synthetic-fibre brush
Turpentine
Alkyd painting medium
The palette:

- *Titanium white*
- *Cadmium red*
- *Quinacridone red*
- *Cadmium yellow light*
- *Cadmium yellow*
- *Pthalocyanine blue*
- *Raw umber*
- *Viridian green*
- *Dioxazine purple*
- *Ivory black*

A bunch of brightly-coloured anemones are casually arranged in a simple earthenware jar. The basic composition is counterbalanced by the brilliance and charm of the subject. A neutral-coloured background ensures that the flowers stand out, their shape and colour unaffected by their surroundings. The relative complexity of rendering each flower is balanced by using the glazing technique that is straightforward and avoids complicated colour-mixing. The white gesso-prepared surface is smooth and bright, ideal for glazing techniques.

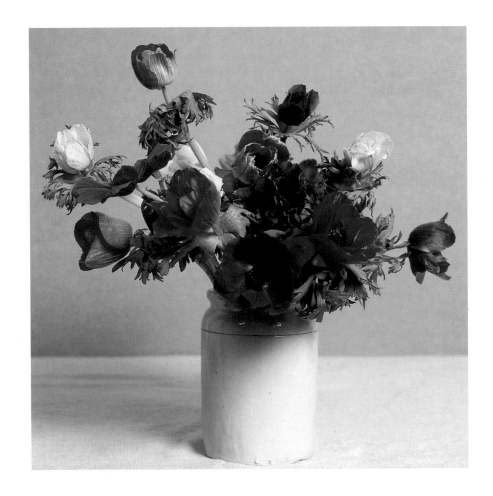

Stage 1: the underdrawing and grisaille

1 Using a sharp pencil, position the flowers and their
container on the panel. Use simple shapes and a fluid line.
Avoid adding too much detail and use a light pencil line.

2 Once you are happy with the position of the subject, you
can elaborate the drawing. Develop the shapes, drawing
in both the form of the objects themselves as well as the
extent and shape of any shadows.

3 The underdrawing is complete.
Erase any mistakes that you think
may show through the relatively thin
applications of paint to follow, and give
the drawing a coat of fixative to prevent
it from being smudged.

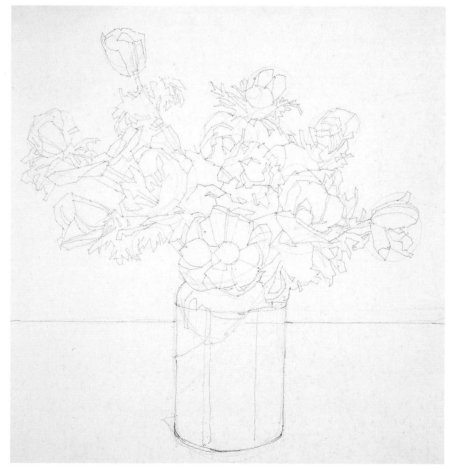

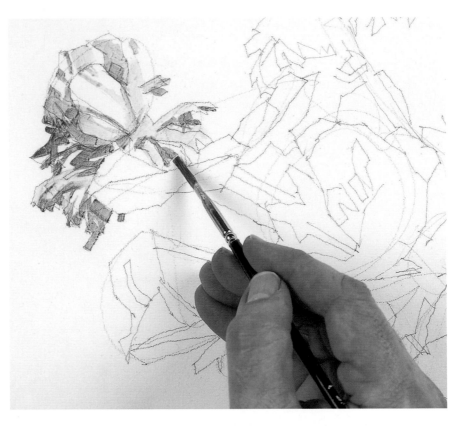

4 Make a grisaille or tonal underpainting using a limited range of greys (see page 31). If you are right-handed, work across the image from the left and vice versa. This prevents you dragging your hand through the wet paint as you work. Use the 6 mm (¼ in) brush and mix four greys using ivory black, a little turpentine and alkyd medium. Your mixes should be of a reasonably fluid consistency, not unlike olive oil. Do not add white paint.

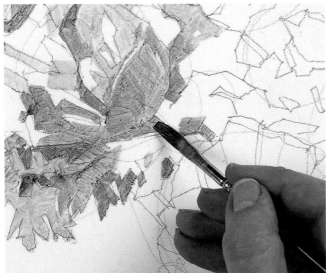

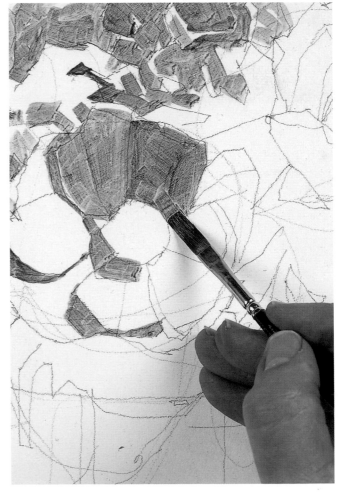

5 Work across the image gradually, carefully painting in the changes in tone. Imagine you are painting a black-and-white photograph.

6 Do not use too dark a grey for the darker tones, as this will read as too dark, or even black, when the colour glaze is applied (see page 54).

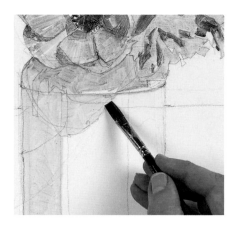

7 Switch to the 12 mm (½ in) brush for the larger areas of tone on the jar. Be aware of any subtle changes in tone and preserve any bright highlights.

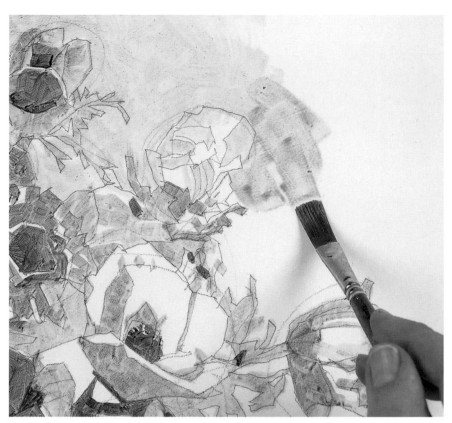

8 Use the 18 mm (¾ in) brush to apply the paint for the light tone of the background and the cloth covering the tabletop. Do not be too concerned about any visible brushmarks.

9 The grisaille is complete. Leave your work to dry at this stage. The fast-drying alkyd medium used in the mixes means this should happen overnight.

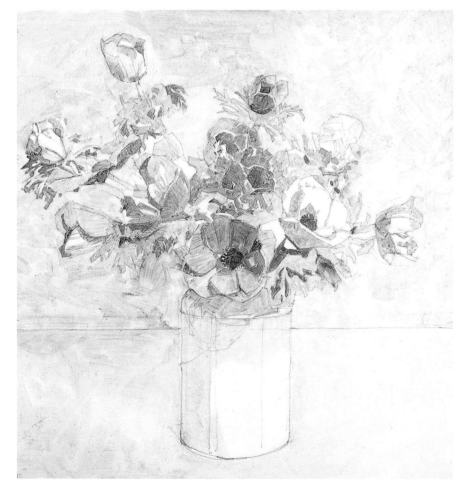

Stage 2: applying the first glaze

10 Mix a mid-red using cadmium red, a little quinacridone red and cadmium yellow light. Make this lighter, or more transparent, by adding more medium and turpentine, and make it darker by adding raw umber. Work your mixes onto the red flower at the top left, using the 3 mm (⅛ in) brush. Note how the tonal underpainting and the added colour work together: the effect is immediate.

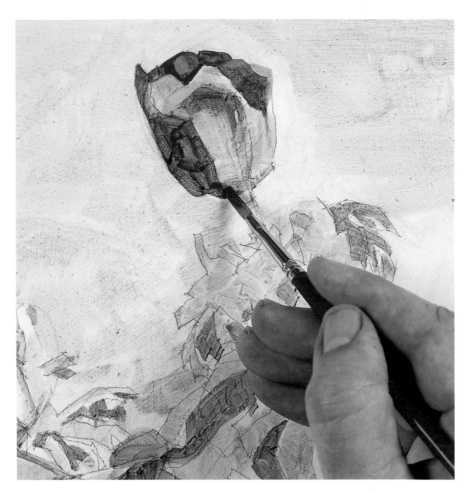

11 Repeat the process slowly, working from one red flower head to the next. Keep the mixes transparent and bright. Even though the underpainting provides the tone, take your time and alter the tone or colour of a glaze if you feel it is required.

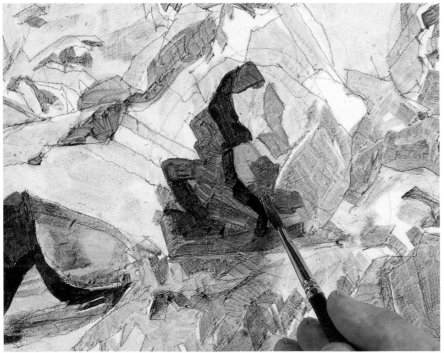

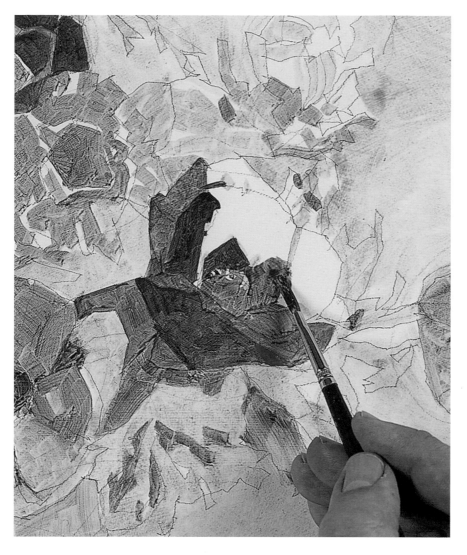

12 Continue to the next red flower. Painting everything that is a similar colour at the same time cuts down on the amount of colour-mixing required. Do not be too concerned about any brushmarks showing through: they add character to the image.

13 Use a dark mix of ivory black with a little pthalocyanine blue to consolidate the dark centre of each anemone flower.

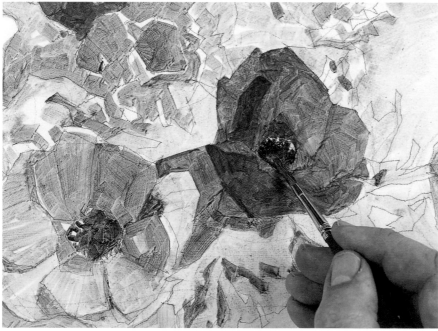

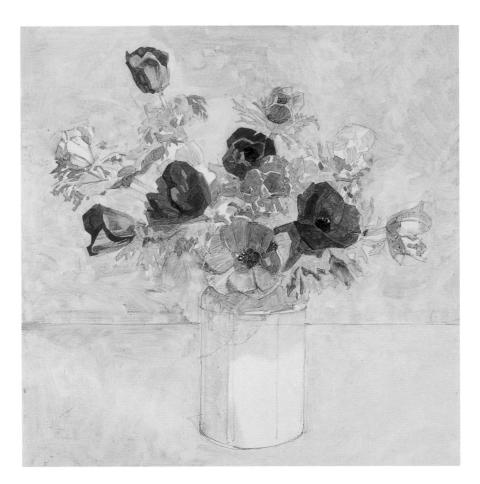

14 Step back from your work. The red flowers stand out from the grey underpainting. Already they have form and look almost complete. This effect will become more pronounced with subsequent glazes.

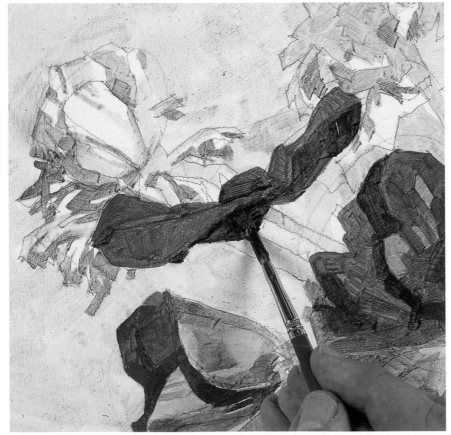

15 Paint the purple flowers in the same way. Mix dioxazine purple with a little quinacridone red and thin the mix to create a glaze using a little turpentine and alkyd medium.

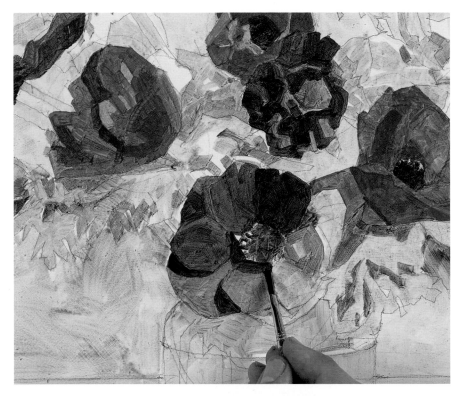

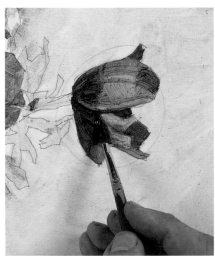

16 Darken or lighten the glaze as required, taking note of the changes in tone. Again, alter the tonal balance as required, simply by darkening or lightening your mixture.

17 As you work across the image, keep the brushwork fluid and avoid going back to apply more paint to previously painted areas that might still be wet to the touch.

18 Use ivory black and pthalocyanine blue to darken the colour at the centre of each purple anemone flower.

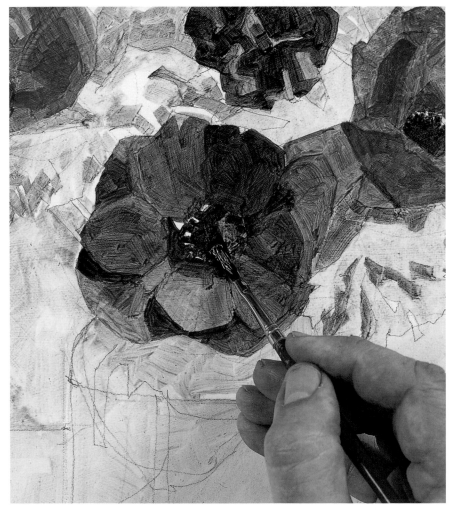

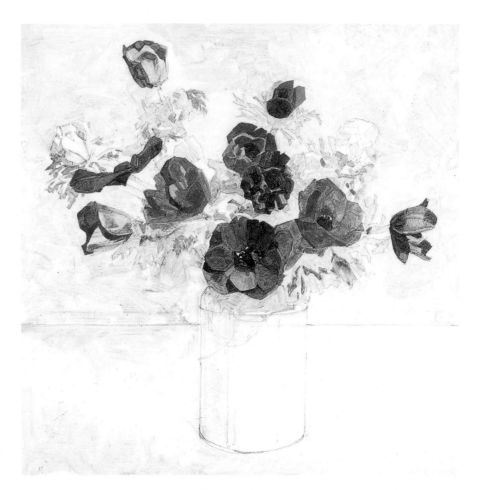

19 The first glaze for all of the red and purple flowers is complete. The image begins to read as it should.

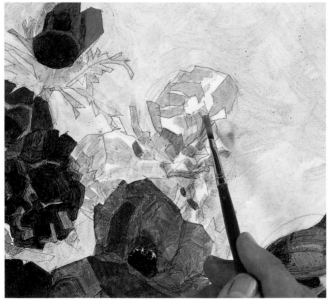

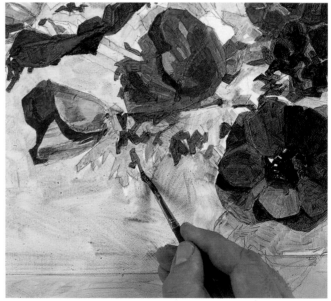

20 The white flowers have a light, yellow-green tinge to them. Mix this using a little cadmium yellow light and a tiny touch of viridian green. Subdue the colour by adding a little raw umber.

21 Mix a dark green using viridian green, cadmium yellow and a little dioxazine purple. Use the 3 mm (⅛ in) brush to paint in the darker leaves and stems carefully. Although you are following the tones painted when the grisaille was prepared, do not be afraid to extend the darker passages if necessary.

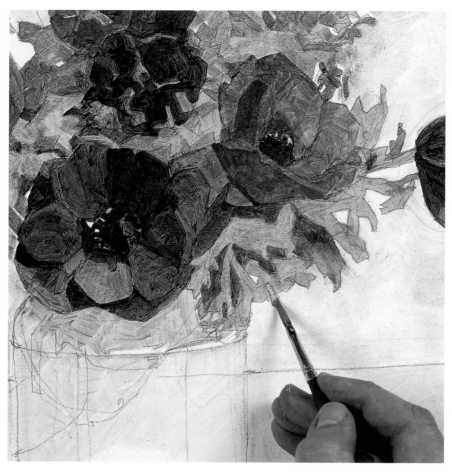

22 Mix a mid-green from viridian green and cadmium yellow light, which you then subdue using a little raw umber. Use this to block in the lighter foliage.

23 Continue the process, working carefully across the image until all of the foliage has been painted.

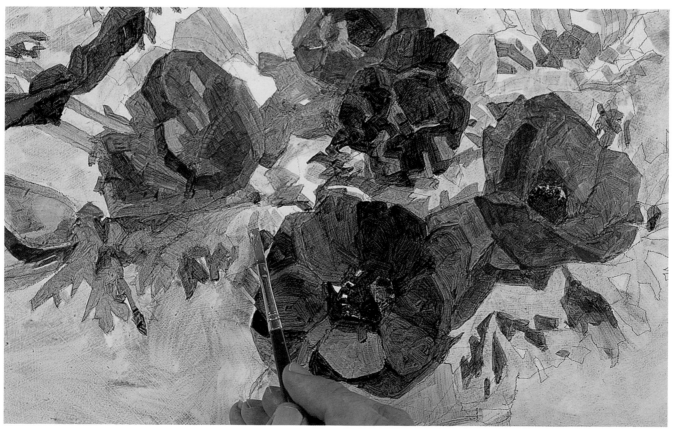

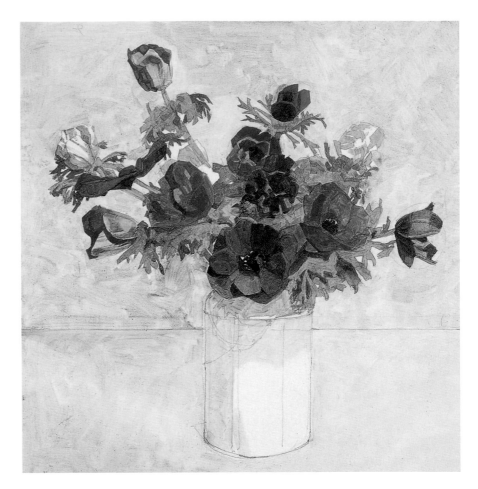

24 The first glaze on both flowers and foliage is complete and, already, the tonal variation and colour combinations are seen to be working successfully.

25 Turn your attention to the jar. Mix a deep, rich brown using raw umber, a little ivory black and dioxazine purple. Using the 12 mm (½ in) brush, paint in the shadows cast by the foliage on the side of the jar.

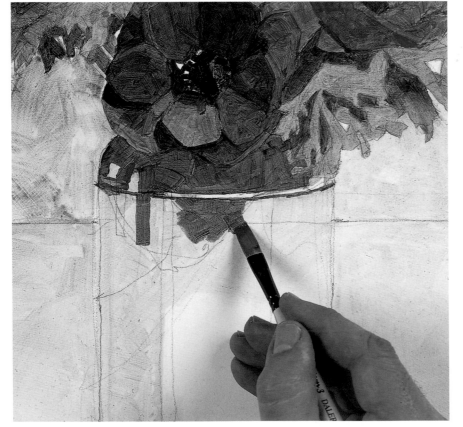

26 Lighten the mix considerably by adding titanium white. (You can add white to these mixes because the underlying tone of the pot is very light and will not look any brighter by using glazing techniques.) Paint in the light colour of the pot.

27 Block in the background using a mix of raw umber, cadmium yellow, cadmium red and titanium white. Carefully cut in around the flowers and foliage, redrawing their shapes using the more opaque paint if necessary. Use the corner of the 12 mm (½ in) brush to get the paint into precise areas, or switch to the smaller brush if you find this difficult.

28 Lighten this mix with titanium white and add a little pthalocyanine blue, then paint in the light cloth covering the table.

29 The first glaze is complete. The tonal balance is correct and the application of colour has brought the painting to life. However, the image looks a little 'washed out': the next layer of glazed colour will intensify the image, making the colours and tones much richer and darker. Allow the painting to dry before continuing.

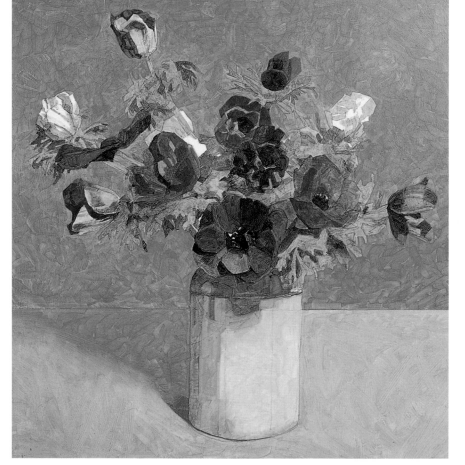

Stage 3: the second glaze

30 Start by repainting the flowers. Mix a bright red using cadmium red and quinacridone red, as before, and rework the red flowers using the 3 mm (⅛ in) brush. Apply the glaze to darken and deepen the areas of the flower in shadow and use precise strokes of glazed colour to add any linear patterns or small changes in colour or tone that can be seen on each flower petal.

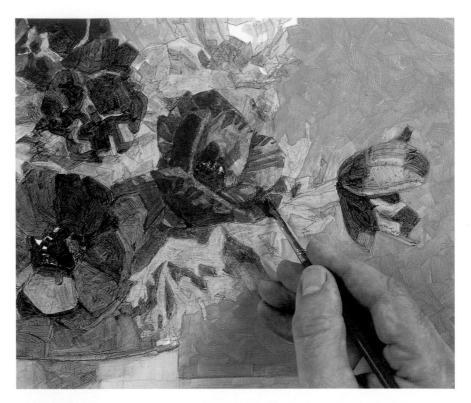

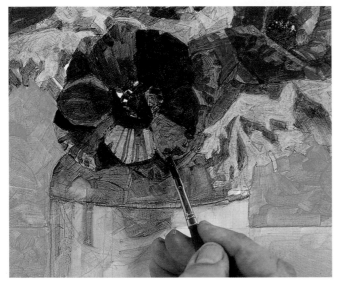

31 Repeat the process for the purple flowers, using a mix of dioxazine purple and ivory black.

32 Rework the white flowers using a dull, light-green glaze. Search out the subtle variations in tone and colour in the slight linear texture or patterns on each flower petal.

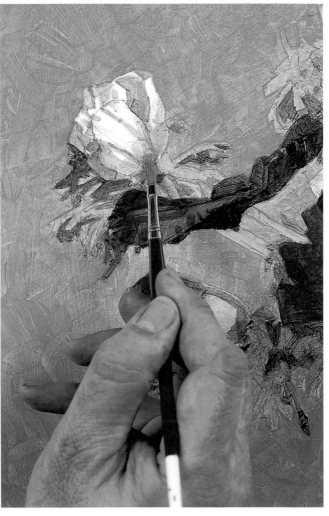

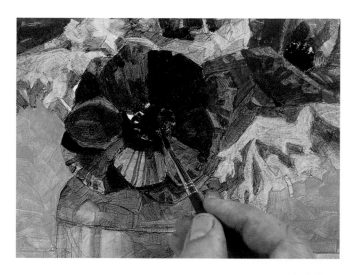

33 Consolidate the centre of each flower using a dark glaze made from ivory black and dioxazine purple.

34 Create a dark green by mixing viridian green, cadmium yellow and raw umber, and use to paint the darker detail and shadows on the leaves.

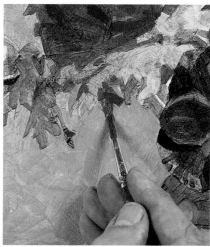

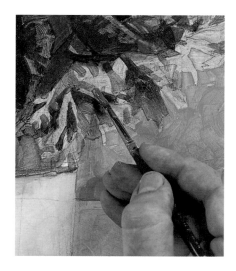

35 Use a slightly lighter green to rework, and add to, the mid-tone detail on both the leaves and flower stems.

36 Apply a dark glaze to the shadows on the jar, using the 6 mm (¼ in) brush. Mix dioxazine purple and raw umber together with a little pthalocyanine blue. Make this mix lighter and more ochre in colour by adding a little cadmium yellow and use to paint the mid-tone shadows.

37 Add plenty of turpentine and alkyd medium to the same mix to create a very pale glaze and use this to paint over the rest of the jar with the 18 mm (¾ in) brush, working around the slightly lighter highlight.

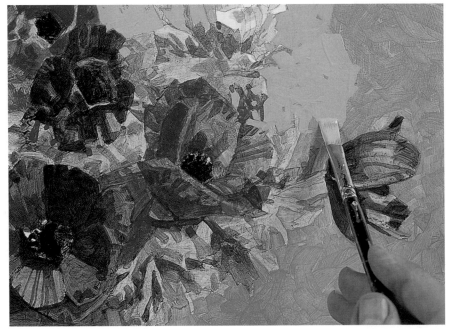

38 Consolidate the background colour. Mix a light ochre using titanium white and raw umber with the addition of a little cadmium yellow and cadmium red. Using the largest brush, carefully cut in around each flower.

39 Use the same mix for the colour of the tablecloth. Add raw umber and a little pthalocyanine blue, and lighten the mixture with titanium white.

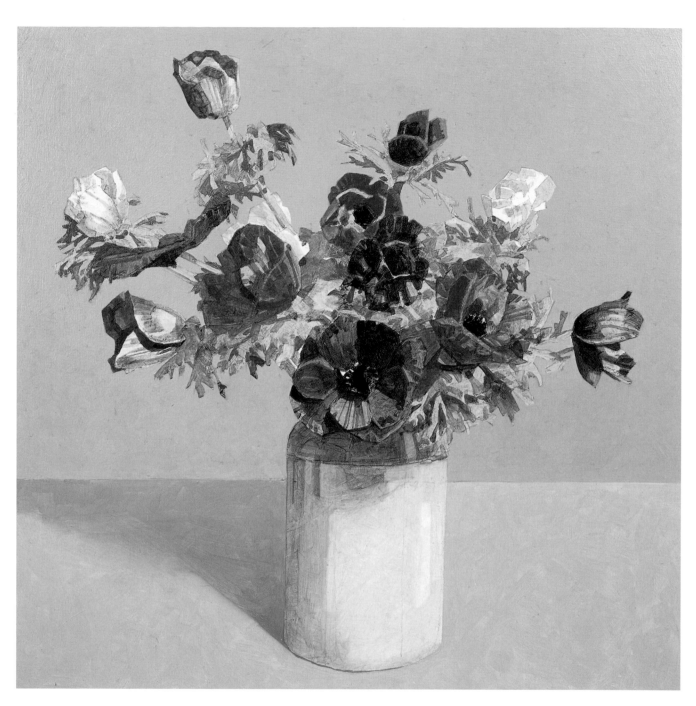

40 The completed image has a brilliance of colour that would have been more difficult to achieve using opaque colour mixes and heavy applications of thick paint.

focus: landscape

Materials

50 x 60 cm (20 x 24 in) prepared
 canvas board

Stick charcoal

Fixative

6 mm (¼ in) flat bristle brush

12 mm (½ in) flat bristle brush

3 mm (⅛ in) synthetic-fibre brush

Small trowel-shaped painting knife

Silicone paint shaper

Turpentine

Alkyd painting medium

Oleopasto or painting butter

The palette:

- *Titanium white*
- *Cadmium red*
- *Cadmium yellow light*
- *Cadmium yellow*
- *Ultramarine blue*
- *Pthalocyanine blue*
- *Raw umber*
- *Burnt umber*
- *Viridian green*
- *Dioxazine purple*
- *Ivory black*

Tall, weather-battered conifers stand straight and tall over dry bracken bathed in the warm spring sun. A band of birch and reeds surround the fringes of a hidden lake. The subject is very 'textural' which makes it ideal for using impasto techniques and expressive brushwork (see pages 68–77). By their very nature, thick-paint techniques preclude a high degree of detail and tend to be more 'impressionistic'. Here, the paint is applied relatively thickly. Oleopasto, a translucent gel that adds body to the paint, is added to the mixes from step 8 onwards.

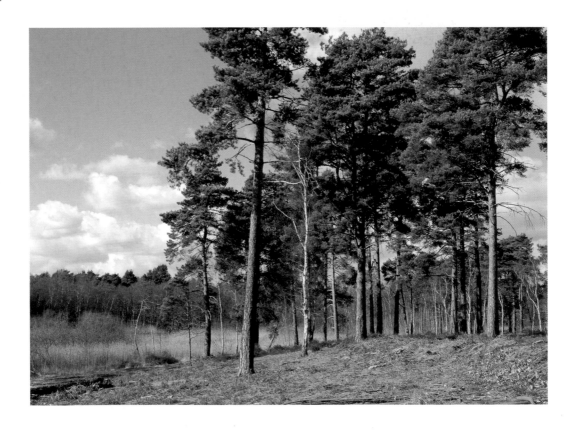

Stage 1: establishing the underpainting

1 A canvas board is used here, because the paint application used for impasto work invariably involves greater pressure and rougher treatment than is, perhaps, the norm. Begin by sketching in the basic elements of the composition, loosely, using stick charcoal.

2 Elaborate the drawing to include areas of deep shadow but do not add any detail: your underdrawing need only be very simple.

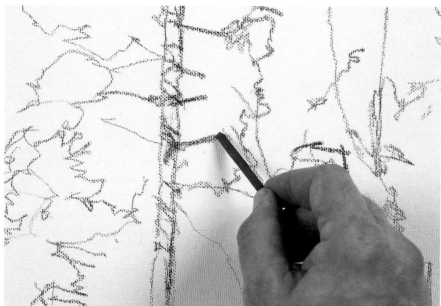

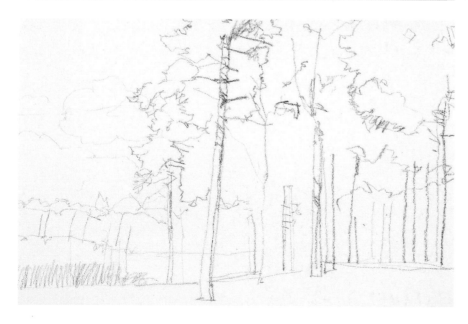

3 Note how the composition follows the rule of thirds (see page 90) with the trees in the foreground taking up two thirds of the width of the drawing, and the line of trees and grasses in the background taking up one third of the height. Once finished, give your drawing a coat of fixative.

4 Make the initial underpainting using thin paint, mixed with turpentine and alkyd medium. Begin by blocking in the green of the trees using the 12 mm (½ in) brush and a mix made using viridian green, cadmium yellow and raw umber.

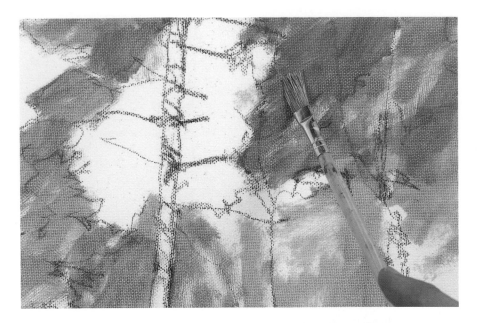

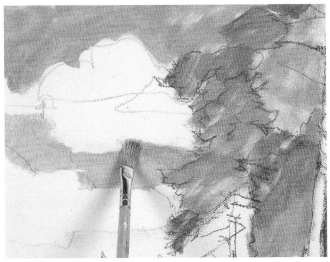

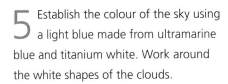

5 Establish the colour of the sky using a light blue made from ultramarine blue and titanium white. Work around the white shapes of the clouds.

6 Make a light brown by mixing raw umber and titanium white, and apply this loosely as a base colour for the trees and grasses in the distance, and the dried bracken in the foreground.

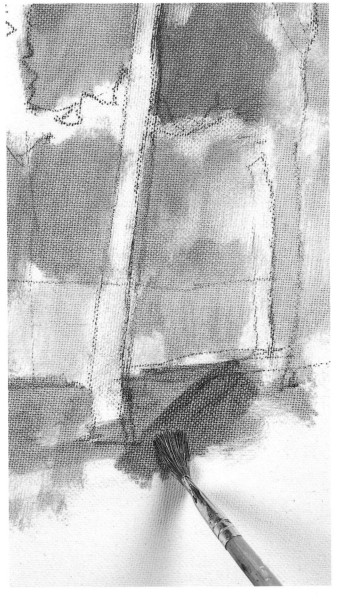

7 The simple, thinly applied underpainting is complete and provides a good base upon which to build the impasto, quickly covering the stark white surface of the canvas board. Stand the board in front of a radiator for a few minutes, to encourage any excess solvent to evaporate. The surface should feel relatively dry, although the paint will still be wet.

Stage 2: working the impasto

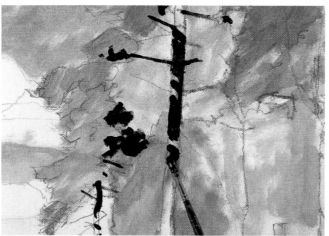

8 Switch to the smaller 6 mm (¼ in) brush and mix a very dark brown using raw umber and dioxazine purple. Use this to establish the main skeletal shapes of the pines and those areas of foliage that are in shadow. Your paint should be of a reasonably thick, creamy consistency: use a little alkyd medium, together with Oleopasto to thicken and extend all of your mixes from here onwards.

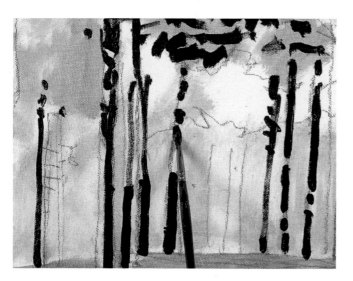

9 Use deft, fluid strokes and only apply the paint to those areas that are in shadow. In order to build up the impasto effect, avoid brushing the paint out too much. Keep filling the brush with plenty of paint and use short, precisely placed brushmarks.

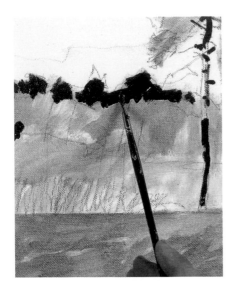

10 Add a little viridian green to the dark-brown mix and block in the line of trees seen running horizontally in the distance.

11 Add more viridian green, cadmium yellow and a little titanium white to lighten the green further, and work this into the pine-tree foliage that is in deep shade.

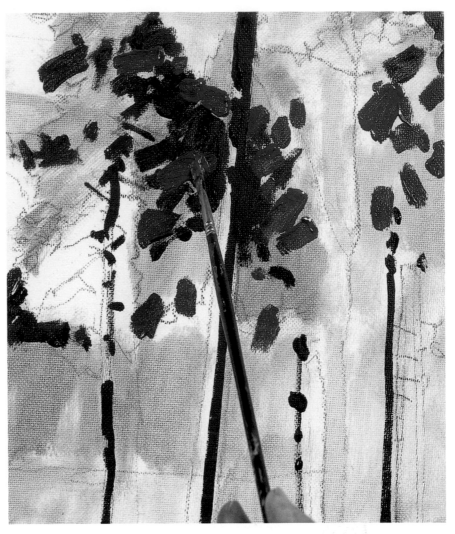

12 Lighten the mix further by adding cadmium yellow light and titanium white. Using the same brush, paint in the mid tones. Use short, precisely placed brushstrokes and vary the angle and direction of each stroke to suit the subject being painted.

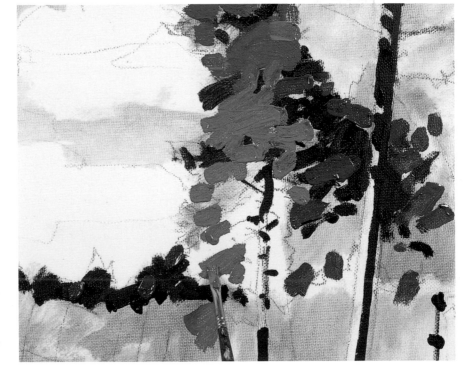

13 Lighten the mix further by adding more cadmium yellow light and titanium white. Continue the build-up of foliage as before, gradually working across the tree canopy.

14 Stand back from the painting. See how the trees have shape and solidity already. The paint, although wet, is relatively stiff, and will enable you to make further applications over the top without destroying or moving the first layer of work too much.

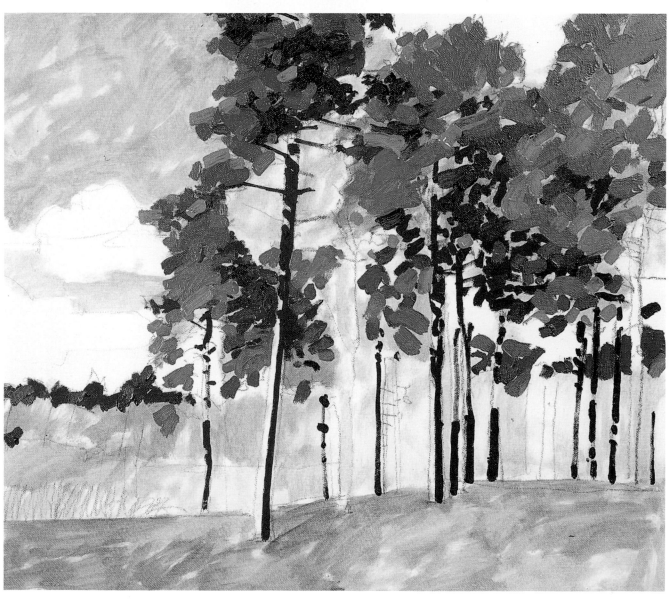

Stage 3: building the impasto

15 Mix a light ochre colour using raw umber, cadmium yellow and a little cadmium red. Lighten this mix using titanium white and use it to establish the band of rushes and trees on the left of the image.

16 Add more titanium white to the mix and, using short strokes of the brush, block in the tops of the dry rushes.

17 Now add burnt umber and a little cadmium red. Use this dull, red-brown to establish the young branches on the distant row of birch trees and the red bloom of the young branches on the birch tree central to the composition.

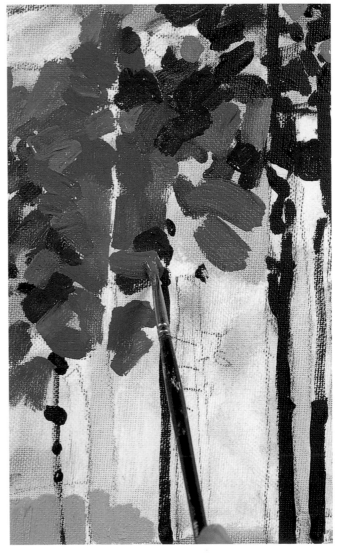

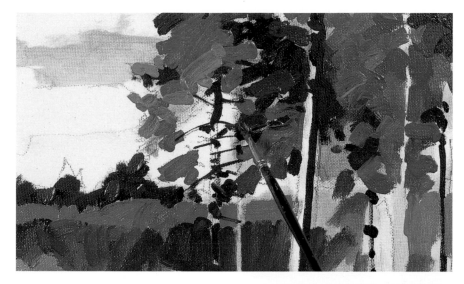

18 Darken this brown mix by adding burnt umber and dioxazine purple, and use the new colour to develop the dark tree branches and the shadows cast onto the trunk of each tree.

19 Add a little titanium white to the mix, together with a little burnt umber, and paint the line of dark dry bracken that runs across the composition, beneath the pine trees.

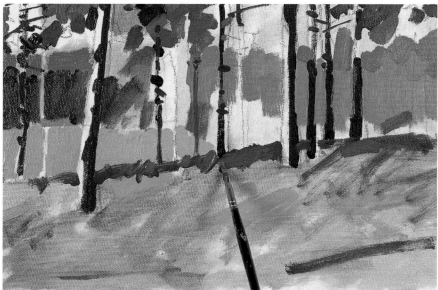

20 Mix a range of ochres and browns and, using the 12 mm (½ in) brush, block in the colours that can be seen across the foreground. Use simple, loosely horizontal, brushwork and broken colour (see page 81).

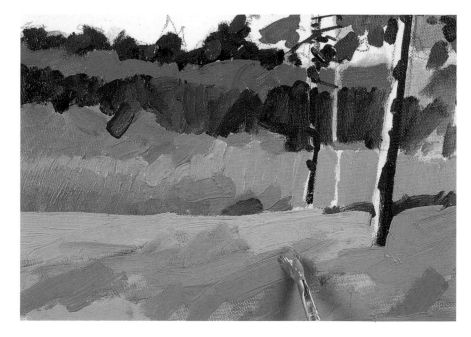

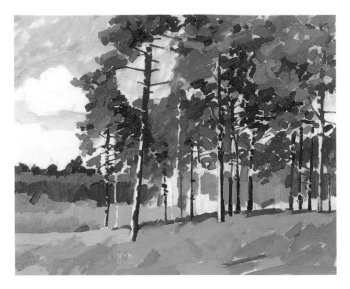

21 Stand back from your painting. Note how the directional brushstrokes help suggest the form of the objects that they represent. The surface texture created by each brushstroke, and the thick paint, help to add interest and contribute to the sense of place and atmosphere.

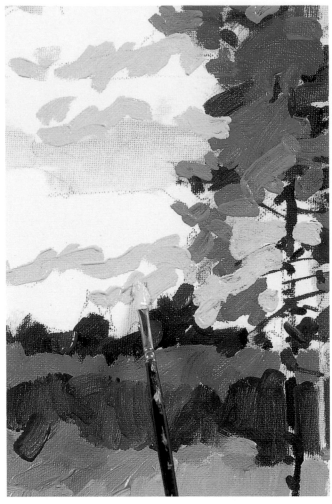

22 Mix a mid-grey using titanium white, ivory black and a little dioxazine purple and use this to establish the mid-grey tones on the clouds with the 6 mm (¼ in) brush.

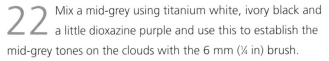

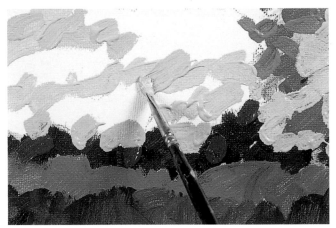

23 Darken the mix a little to paint the darker tones at the base of each cloud. Use fluid, directional brushstrokes to describe the fluffy forms.

24 Mix a little of the grey with titanium white and, using the 12 mm (½ in) brush, make a series of flowing, curving strokes to suggest the light sections of each cloud.

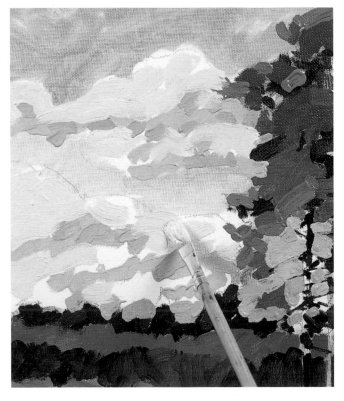

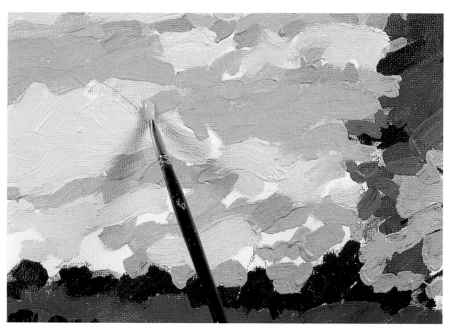

25 Now repaint and darken the blue sky, using the 6 mm (¼ in) brush and a mix of titanium white with a little ultramarine blue and a touch of light grey to subdue the colour slightly.

26 Stand back from your work. See how it begins to read from 'front to back' and has a sense of depth and atmospheric, or aerial, perspective. The energetic brushwork adds a sense of movement making the clouds appear to be actually moving across the sky.

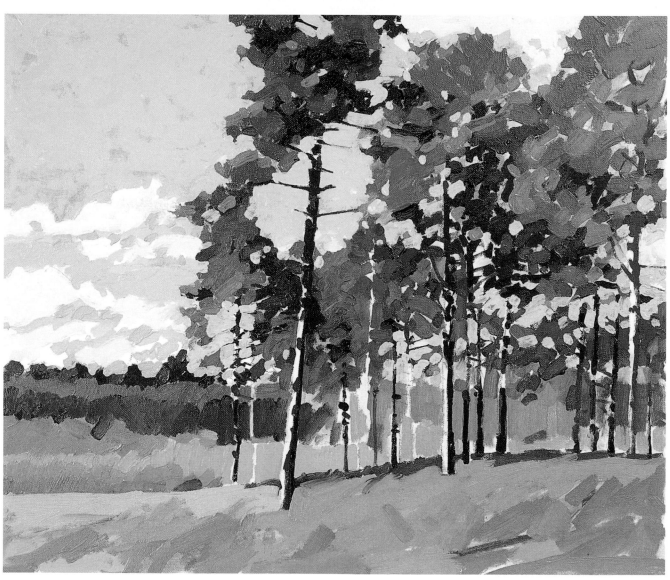

Stage 4: adding definition and detail

27 Mix a light brown using raw umber and titanium white and use this, with the small 3 mm (⅛ in) brush, to define and tidy the light side of each pine tree trunk. Use the same mix to paint in the light bark of the thin birch trees with short, precise strokes.

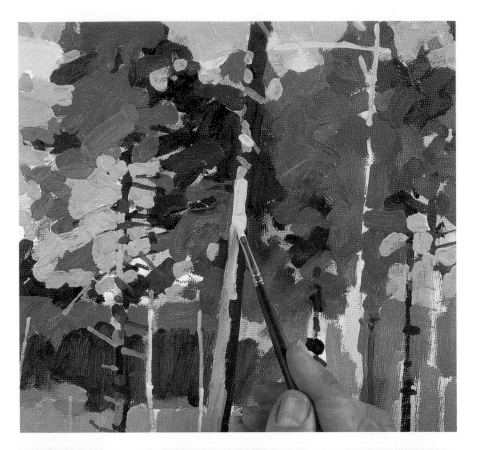

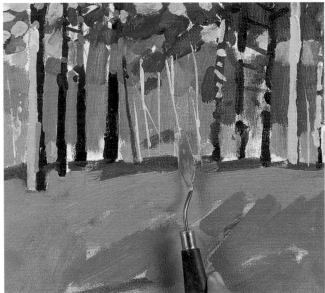

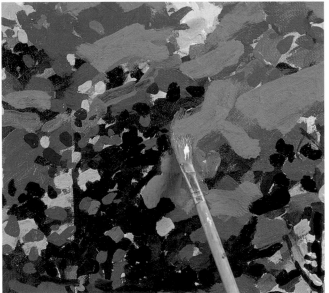

28 Switch to the painting knife to render the light bark of the trees that stand out against the darker mass of trees in the distance. Pick up a little paint on the very edge of the knife and run the edge over the appropriate area to achieve a thin straight line. To alter the direction of the line, simply change the direction of the knife stroke. You can practise this on a piece of paper before marking the canvas.

29 Make a light, bright green using viridian green, cadmium yellow light and a little raw umber with titanium white to subdue its brilliance. Using the larger 12 mm (½ in) brush apply this in fairly large strokes onto the foliage of the pine trees. These slabs of colour add substance and solidity to the trees and increase the spatial effect by making them appear to come forward.

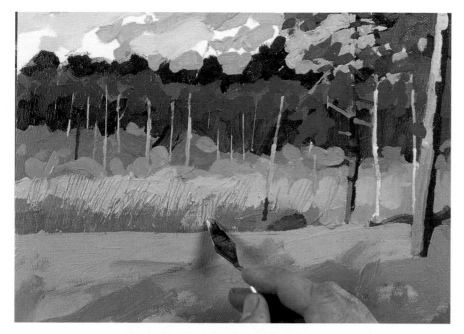

30 Mix a selection of browns and ochres and, using the 6 mm (¼ in) brush, rework the distant tree line and the bed of rushes. Now use the painting knife to scratch through the light ochre of the rushes to create a series of slightly curving, vertical marks to represent the individual grasses.

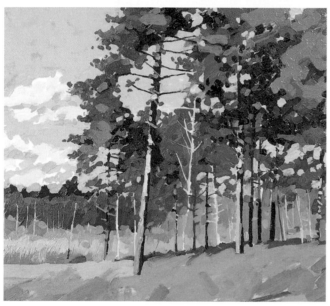

31 The painting is almost finished, although the canvas can still be seen showing through in places. You can easily remedy this by working over the image with judicious strokes of appropriate-coloured paint.

32 Apply a light blue, mixed from titanium white, ultramarine blue and a little pthalocyanine, to the sky using the 6 mm (¼ in) brush. Use the same, curving, fluid brushstrokes that you used for the clouds. Adjust the shape of the clouds as you work, if desired.

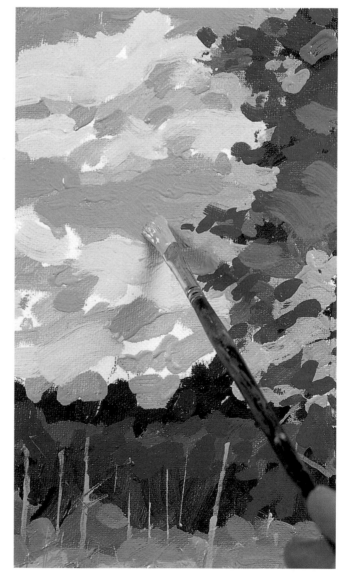

33 Mix pure titanium white with a little Oleopasto and alkyd medium for the whitest parts of the billowing clouds and apply using the same fluid strokes.

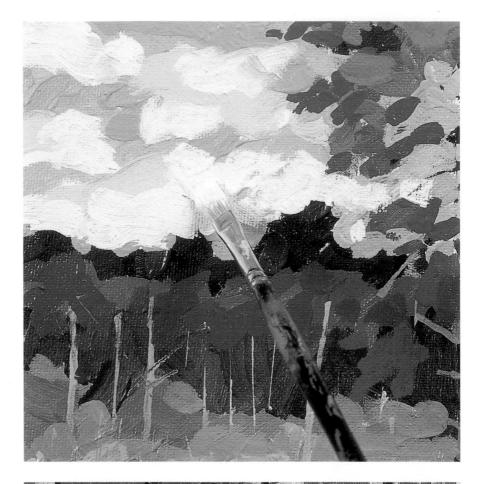

34 Loosely scrub a range of light ochres and browns onto the area in the foreground and work into the paint, manipulating it using the paint shaper. This helps to create the impression of the dry and broken forest-floor debris littering the area beneath the trees.

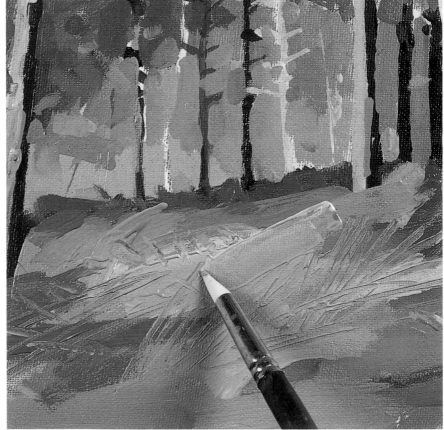

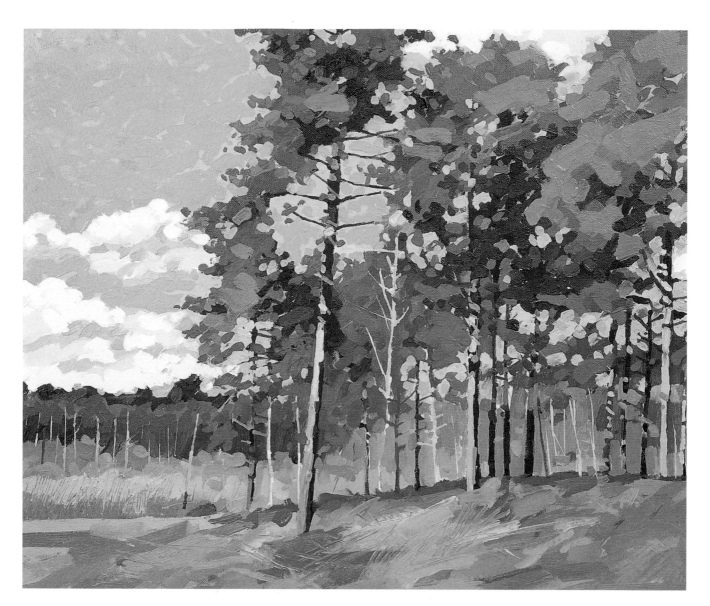

35 The completed painting. The impasto technique suits the subject and allows a fairly rapid approach, which captures both the character and atmosphere of the place. Although the applications of paint are quite thick, they should dry within a few days owing to the addition of the quick-drying alkyd and Oleopasto painting mediums. Once dry, you can work on the painting further, increasing the thickness of paint as desired.

index

acknowledgements

Executive Editor Katy Denny
Editor Lisa John
Executive Art Editor Penny Stock
Designer Martin Lovelock
Production Manager Ian Paton
Artist Ian Sidaway
Photography Ian Sidaway and Colin Bowling © Octopus Publishing Group Limited